Fashion

For every girl whose parents never wanted them to choose a life in fashion.
This one's for you.
—L.C.

For Kara, Sophie, and Bean.
—C.C.

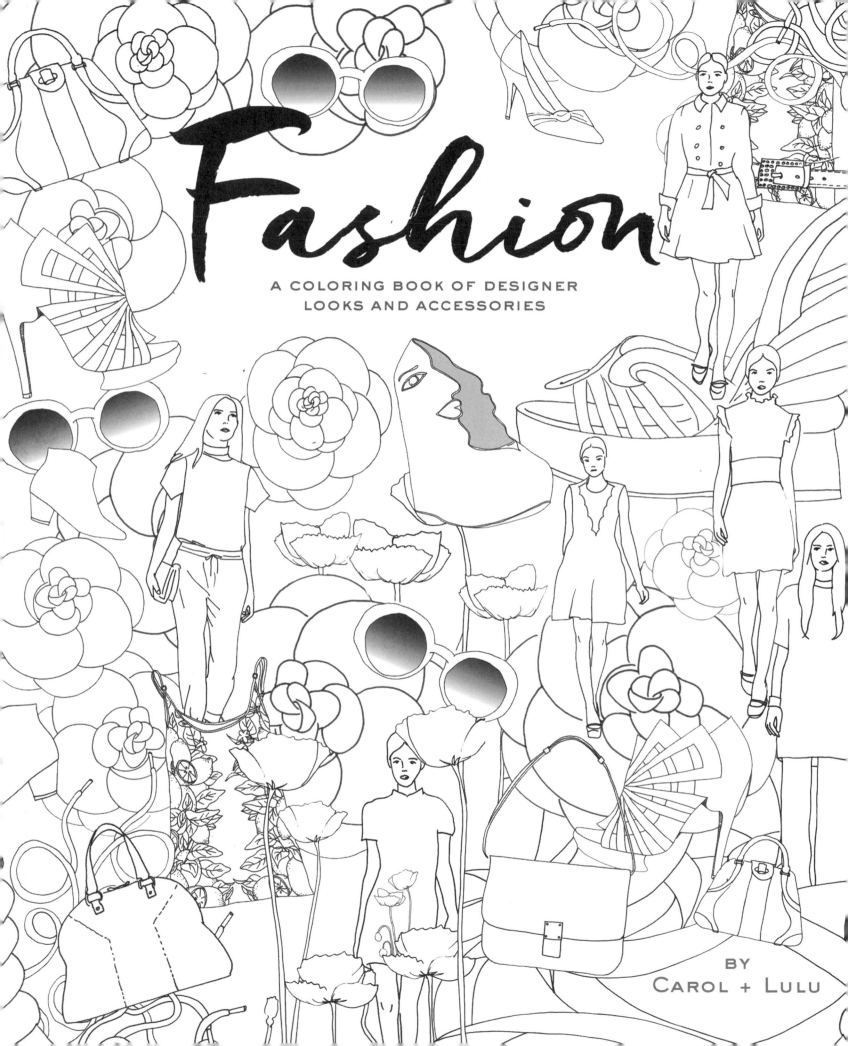

Fashion

A COLORING BOOK OF DESIGNER LOOKS AND ACCESSORIES

BY
CAROL + LULU

All hail one of the greatest designers of our time—the late **Alexander McQueen.** Whether regal or rebel—McQueen was never afraid to color outside the lines. Honor fashion royalty by coloring his most memorable looks.

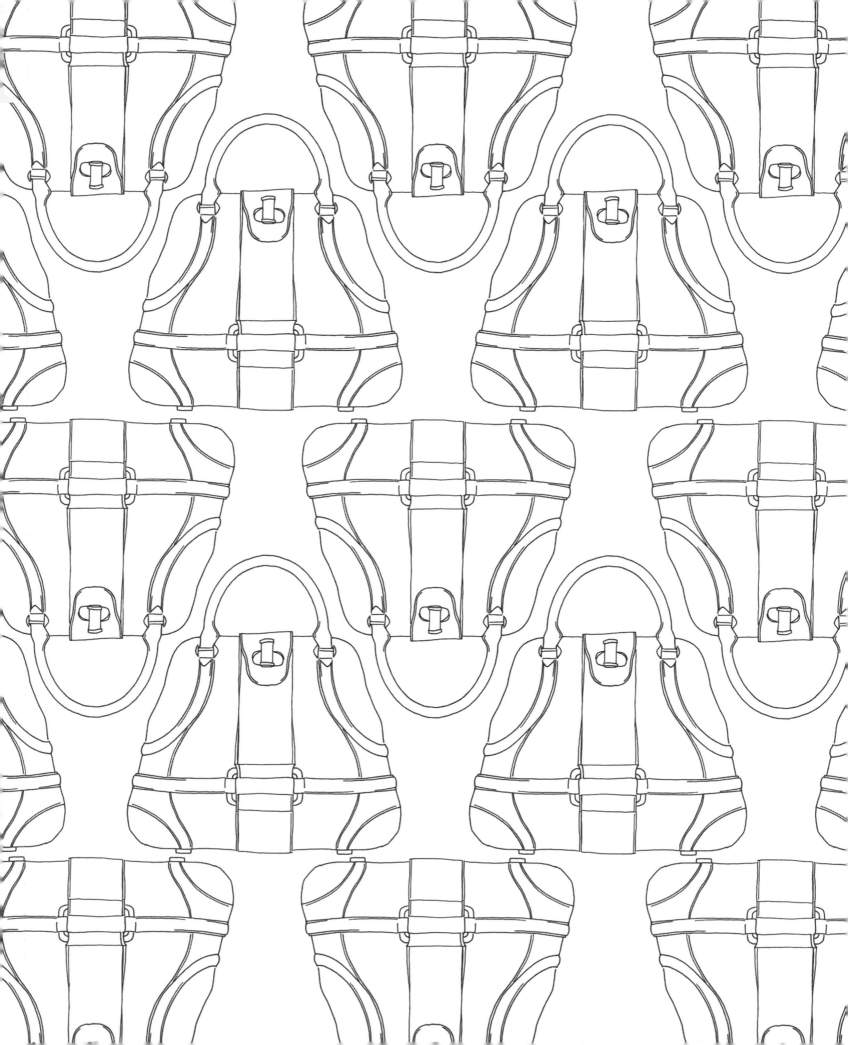

"It's a new era in fashion—
there are no rules."
—*Alexander McQueen*

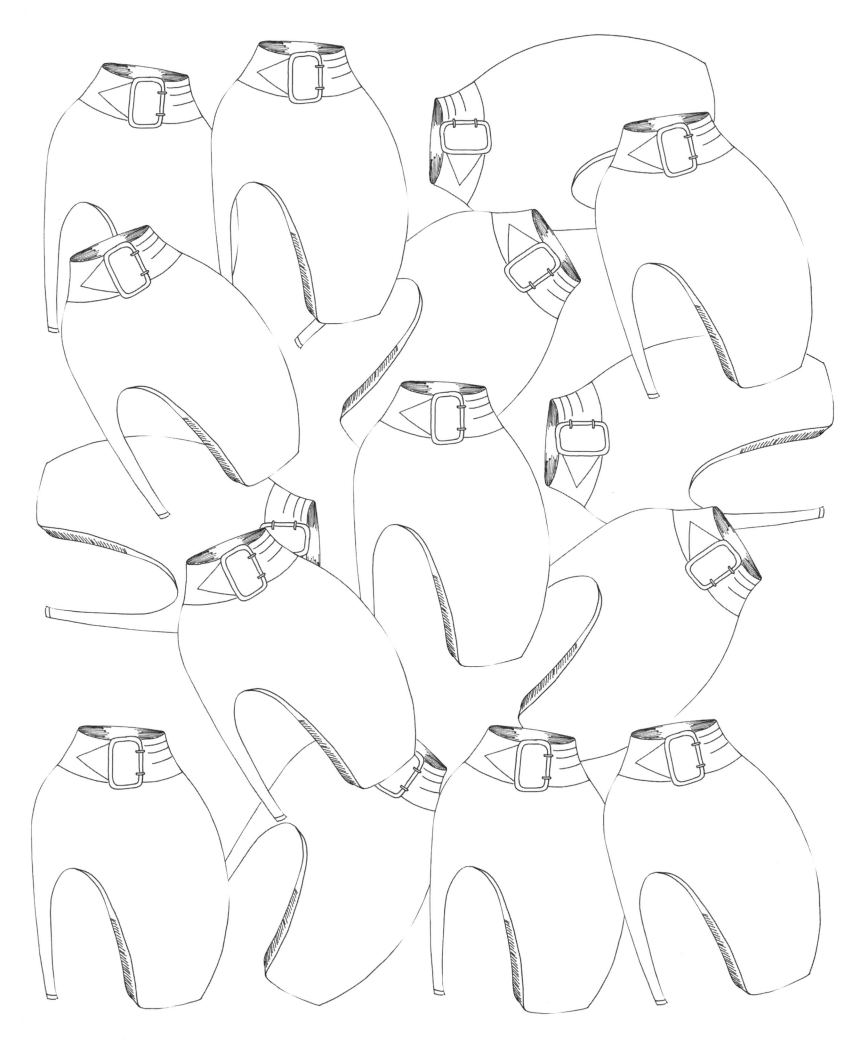

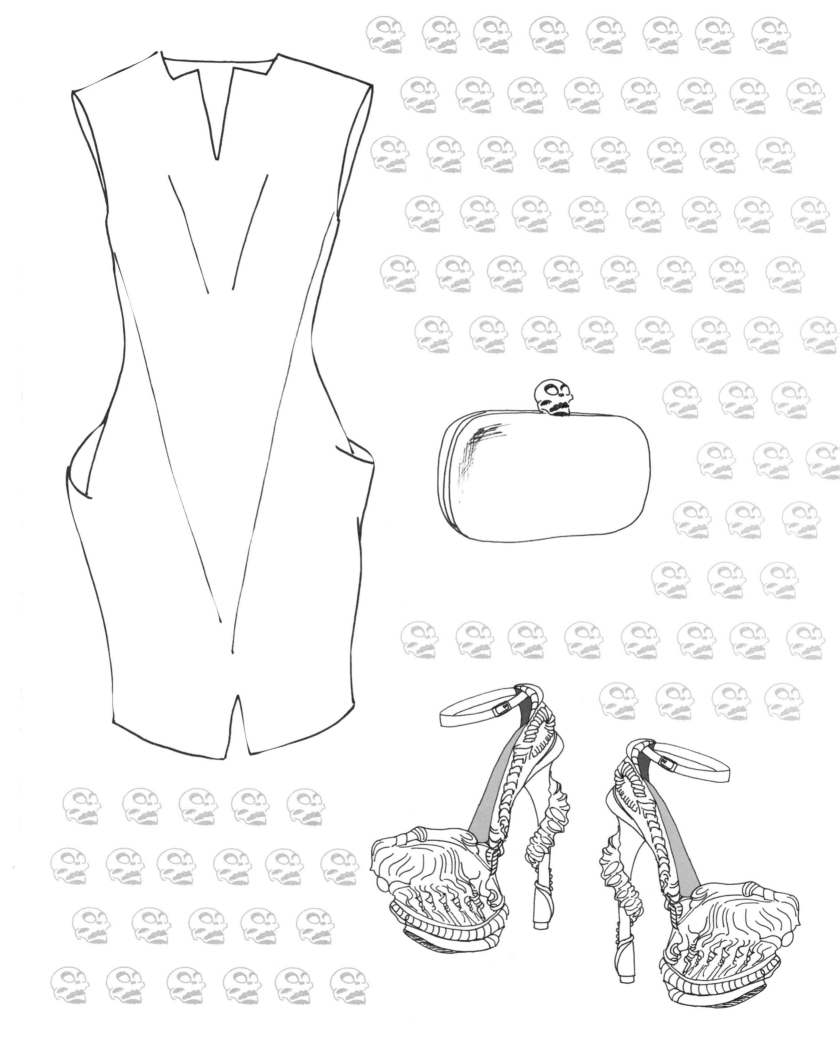

Get back to your roots — hair roots, that is. Britain's **Giles Deacon** knows about a head-to-toe look. Add colorful streaks to this shaggy 'do and complete the sixties cartoon vibe. You dig?

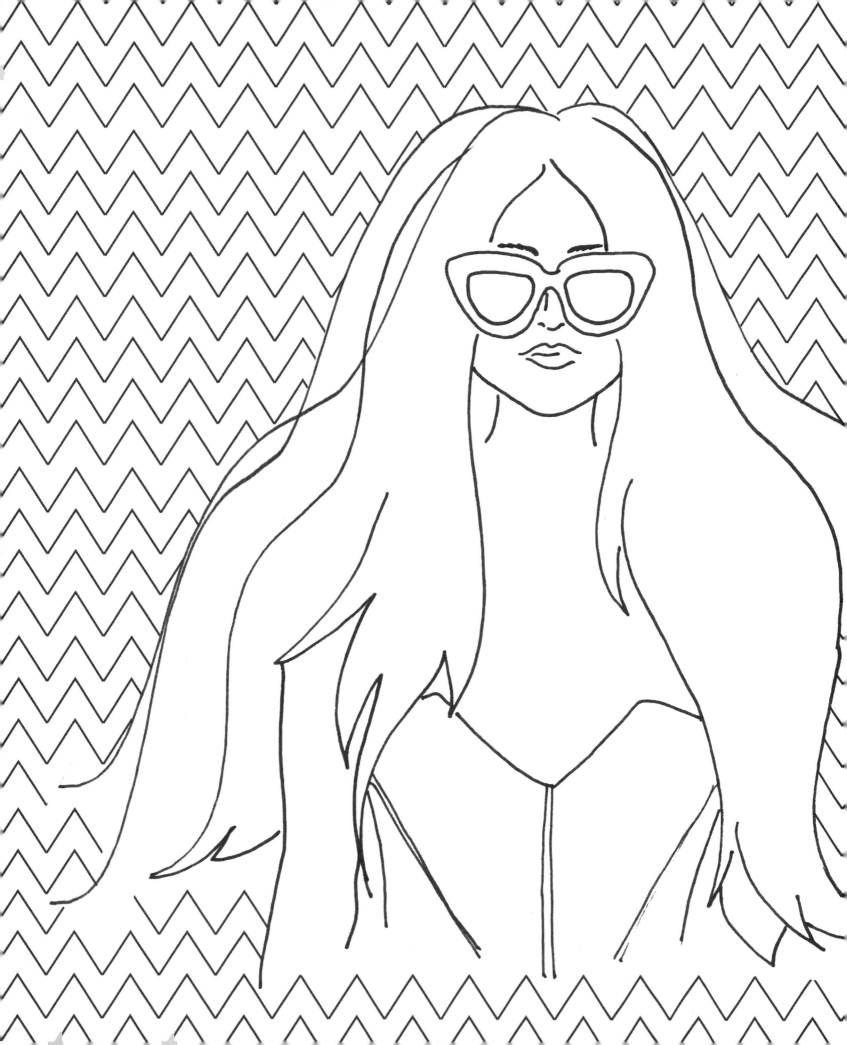

Help **Charles Anastase** collect all the fairies . . .
Color in their fine, fanciful frocks.

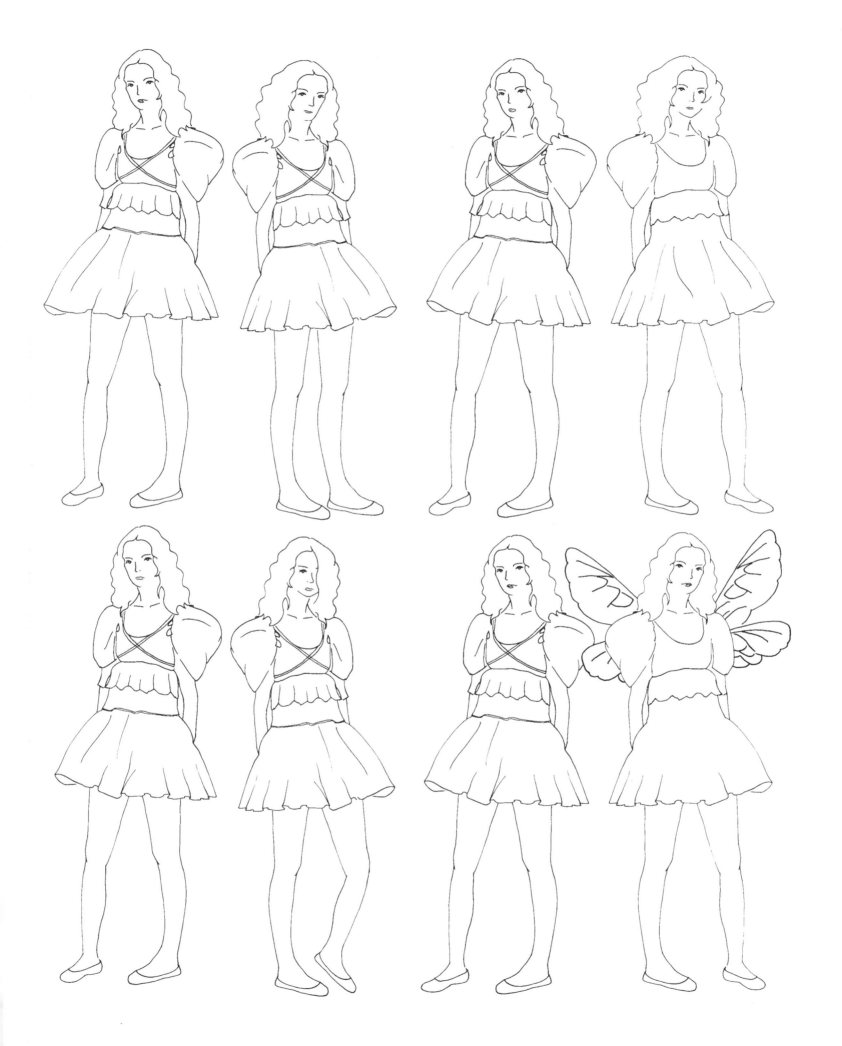

"I'm looking for a woman who can represent my idea better than any other."
—*Miuccia Prada*

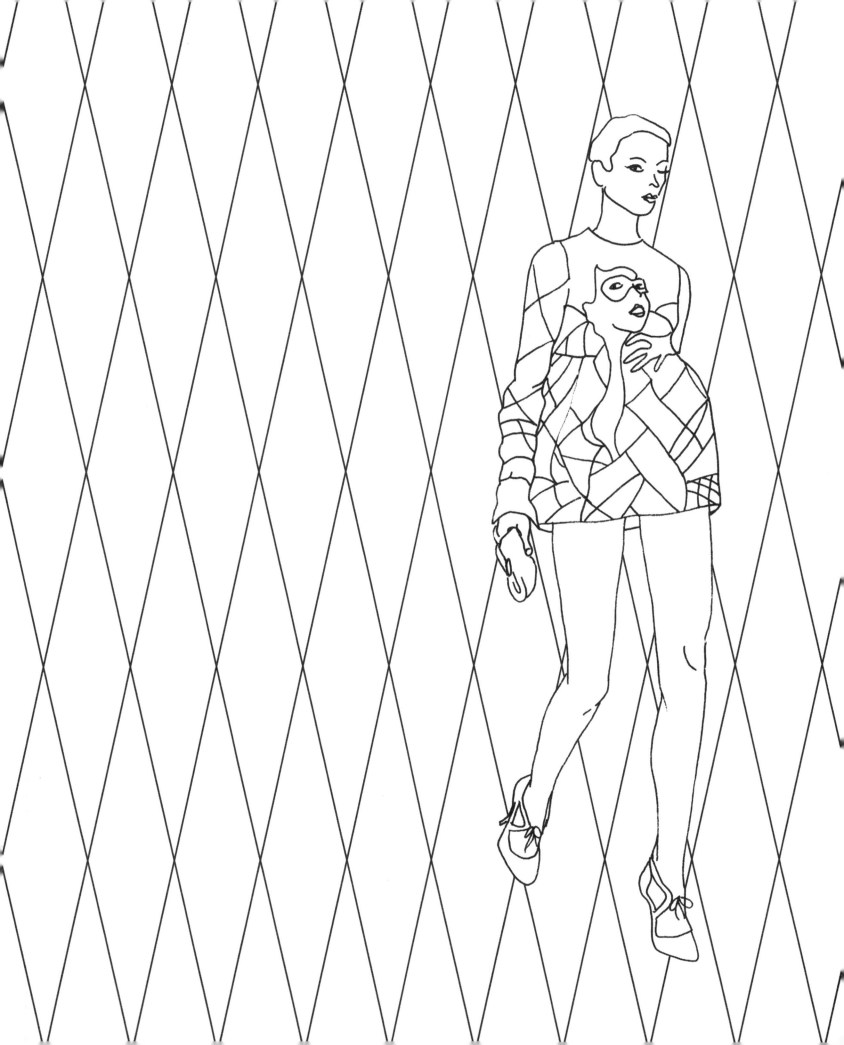

Respect your fashion heritage—even the simplest garment has a journey.
Color the different **Levi's** looks from American tradition to fashion staple.

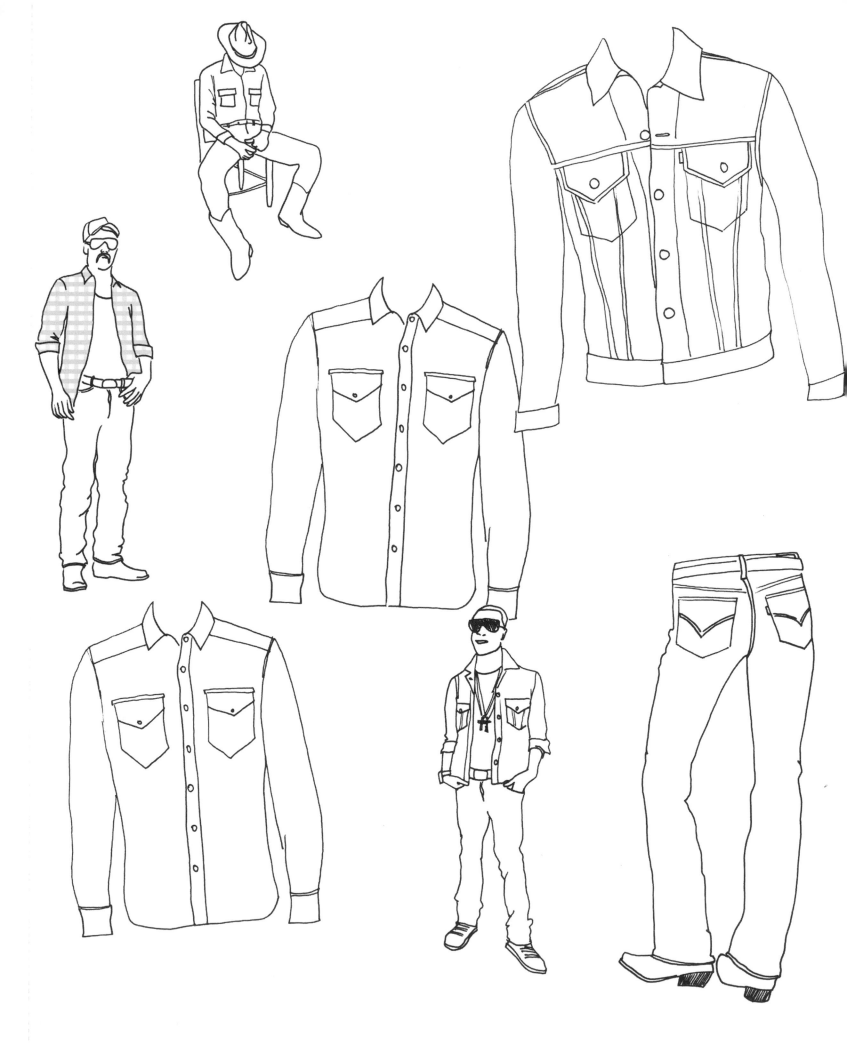

"Too much is never enough."
—*Luella Bartley*

Don't show up at a party looking the same as someone else. The designer **Luella Bartley** believes fashion is about individuality. Customize each girl's party dress with Luella's sweet and girly accessories.

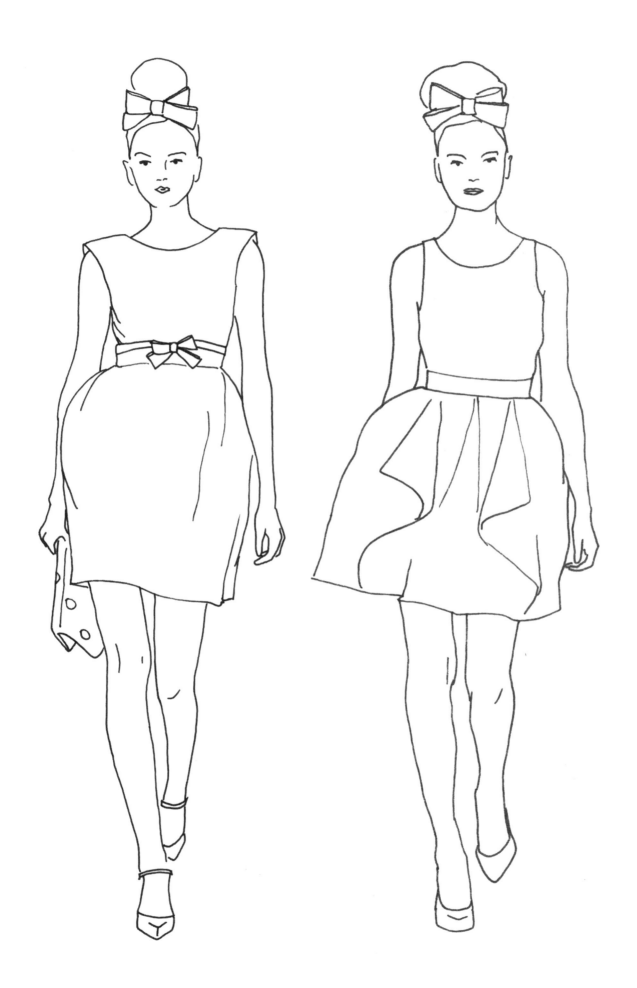

A girl can never have too many shoes.
Color these covetable creations by
Miu Miu . . .

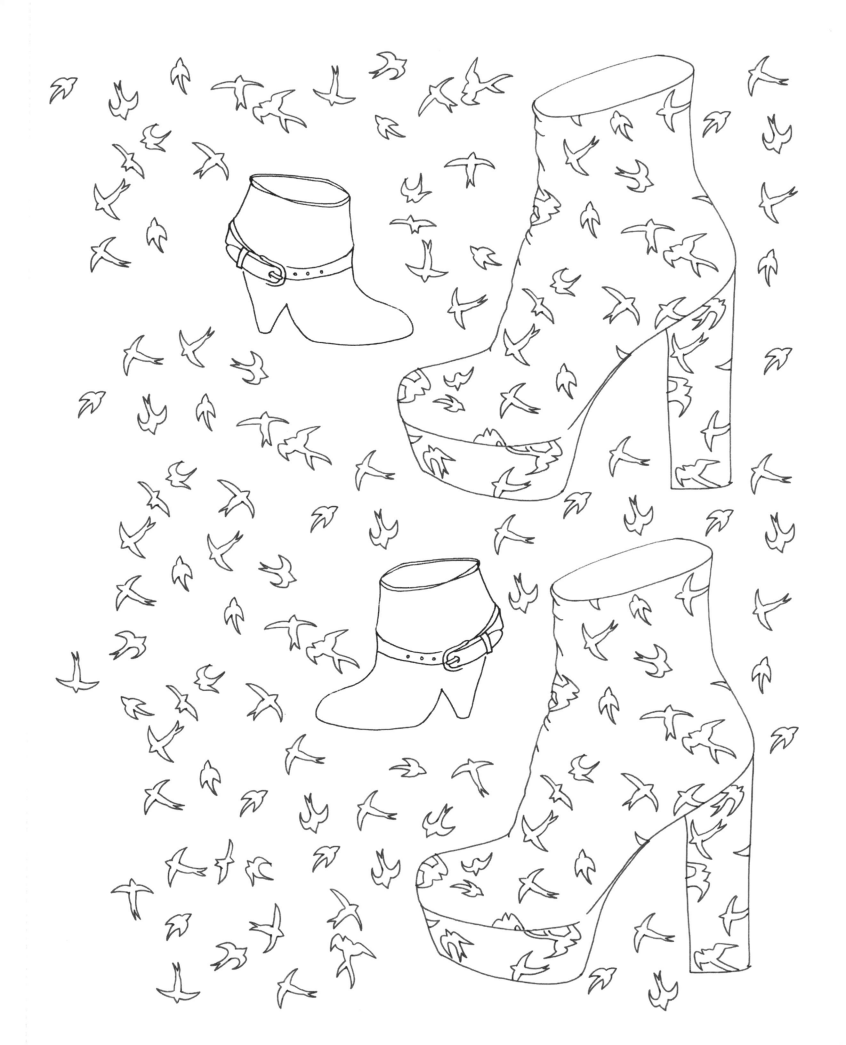

Terry de Havilland . . .

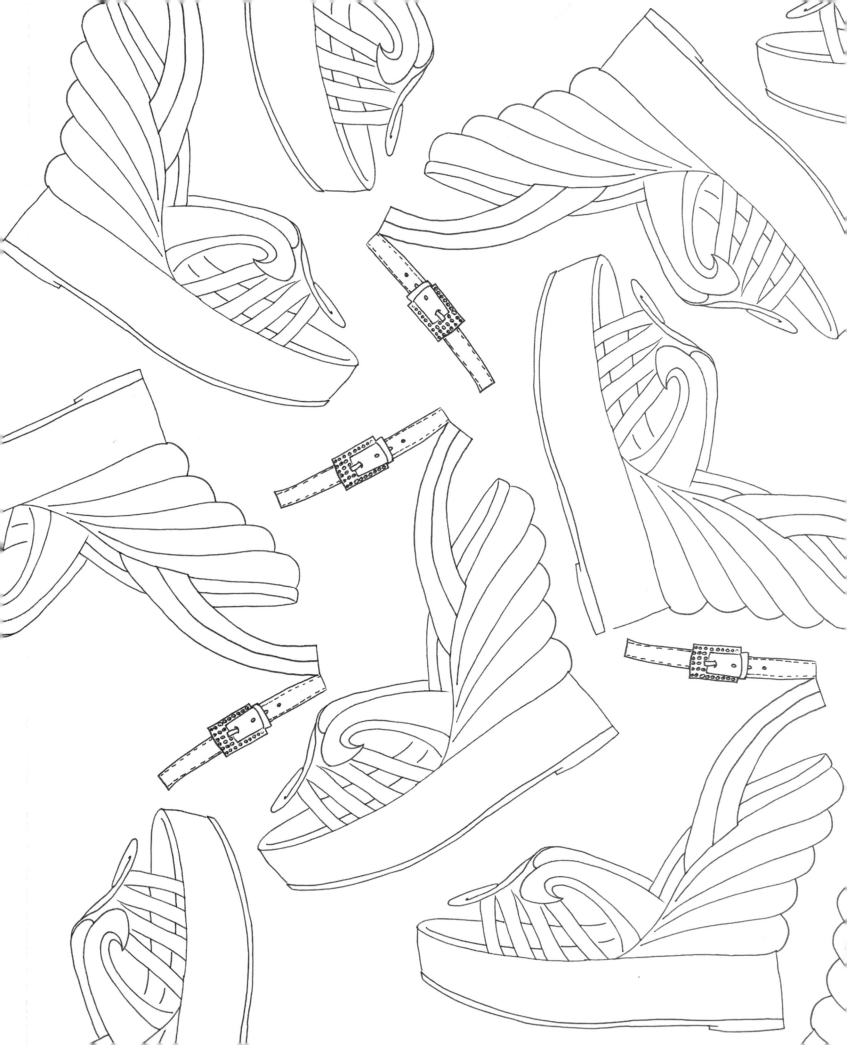

Nicholas Kirkwood . . .

Christian Laboutin, and more!

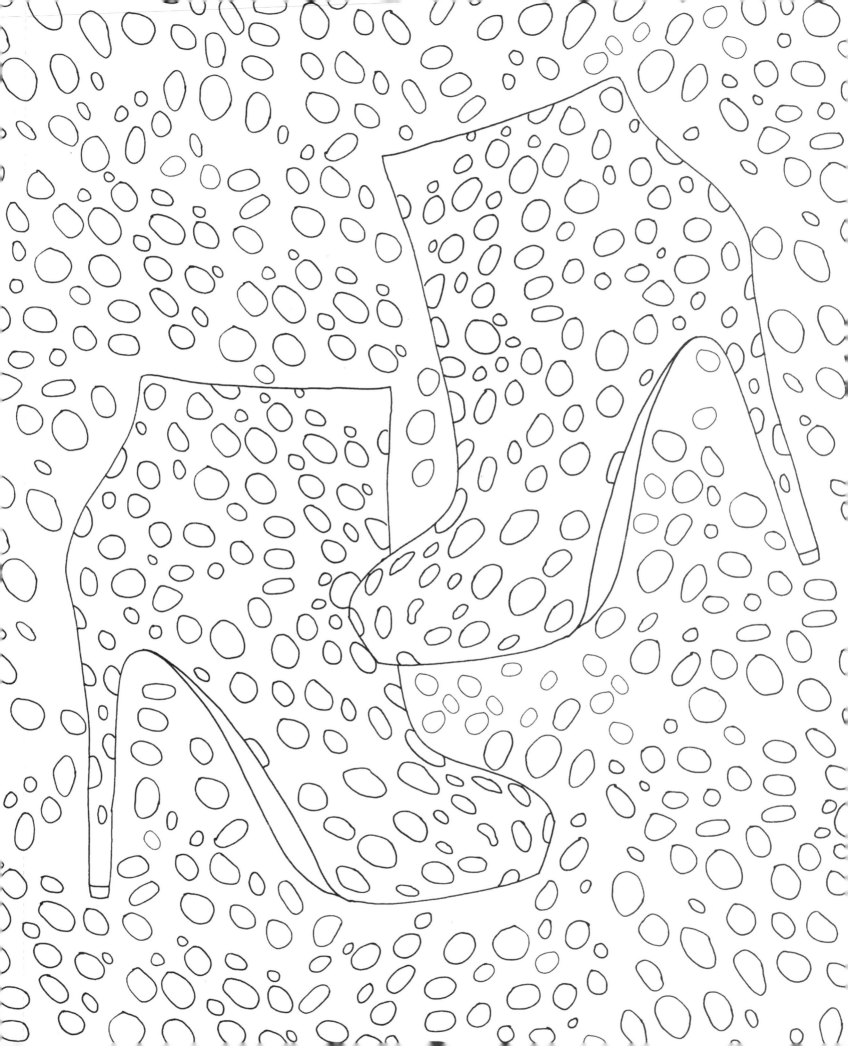

"When accessorizing, always take off the last thing you put on." —*Coco Chanel*

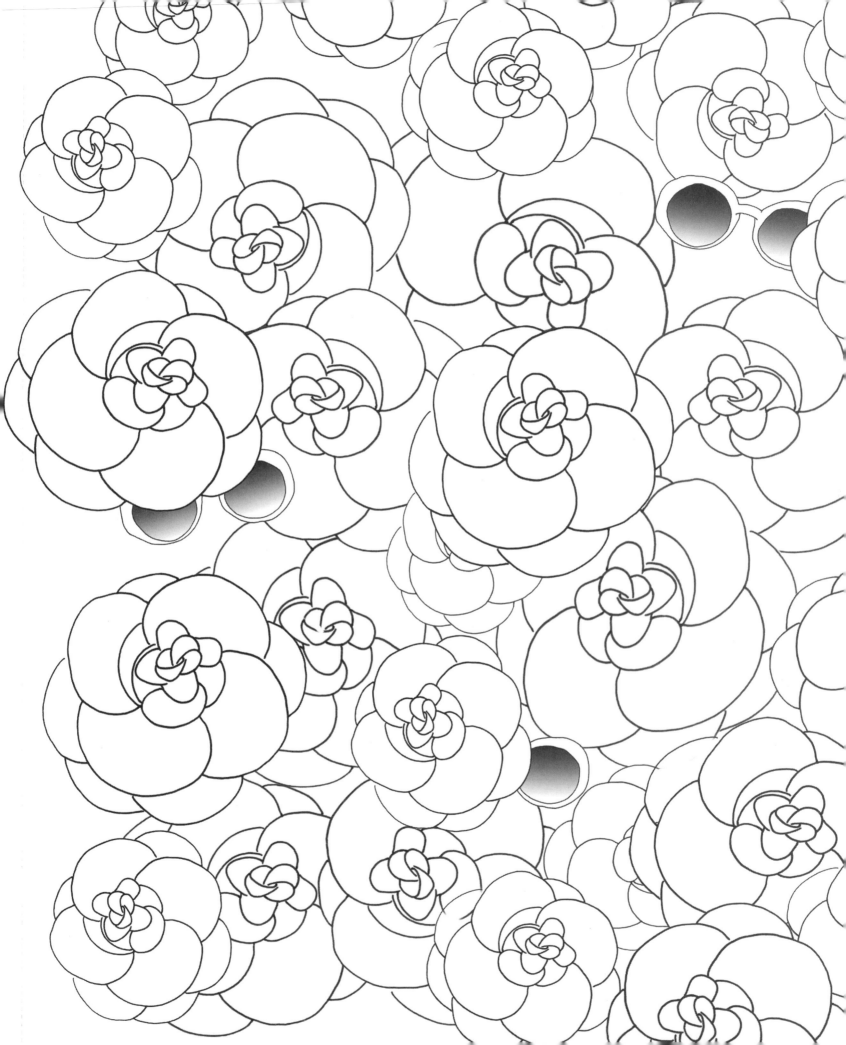

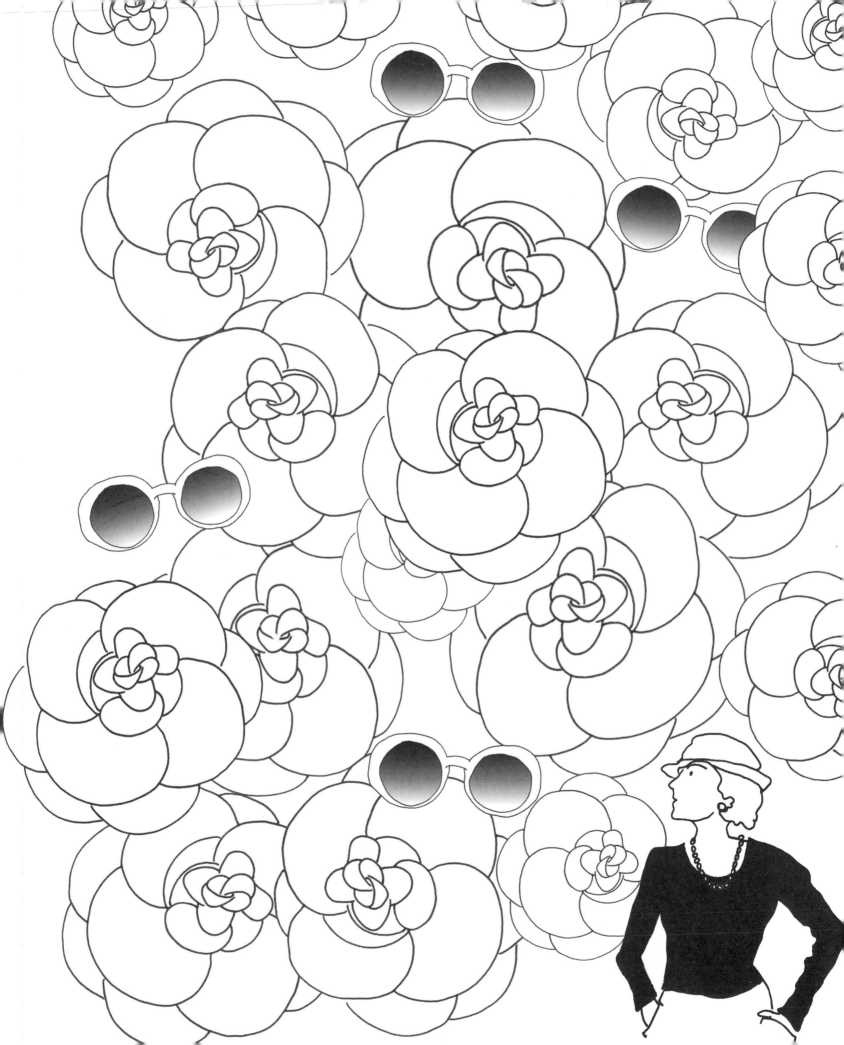

What's up, Doc? The '90s are back and so is the **Doc Martens** shoe. Stomp around town in these classic eight-hole boots. Color your way through the laces.

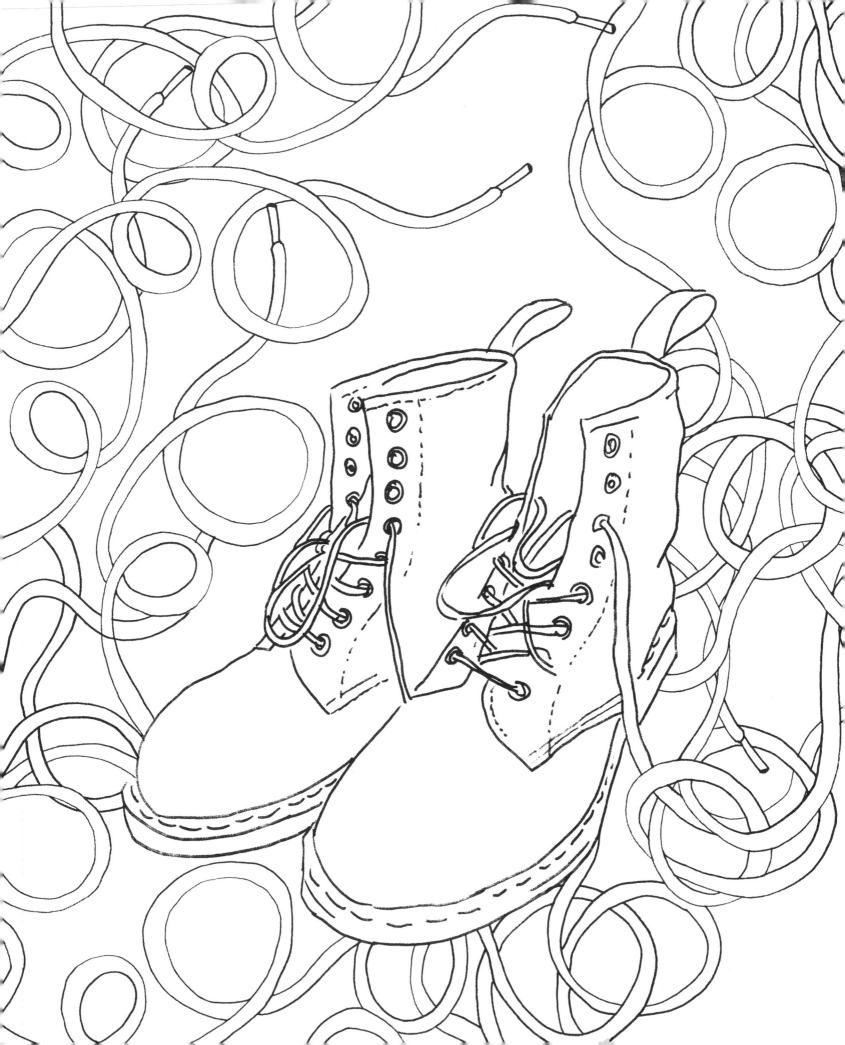

Color in these iconic, classic bags.

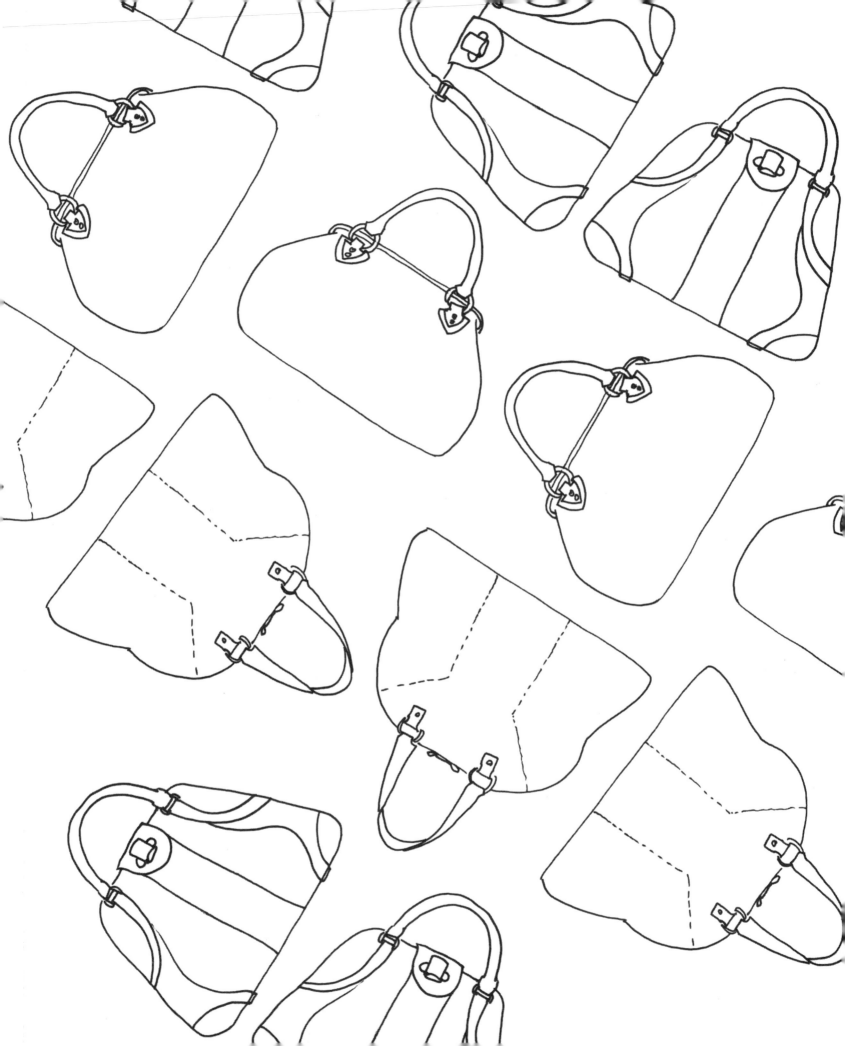

Whether you're trying to look cool or just hiding from the sun, **Ray-Ban** has you covered. They've been making sunglasses since 1937!

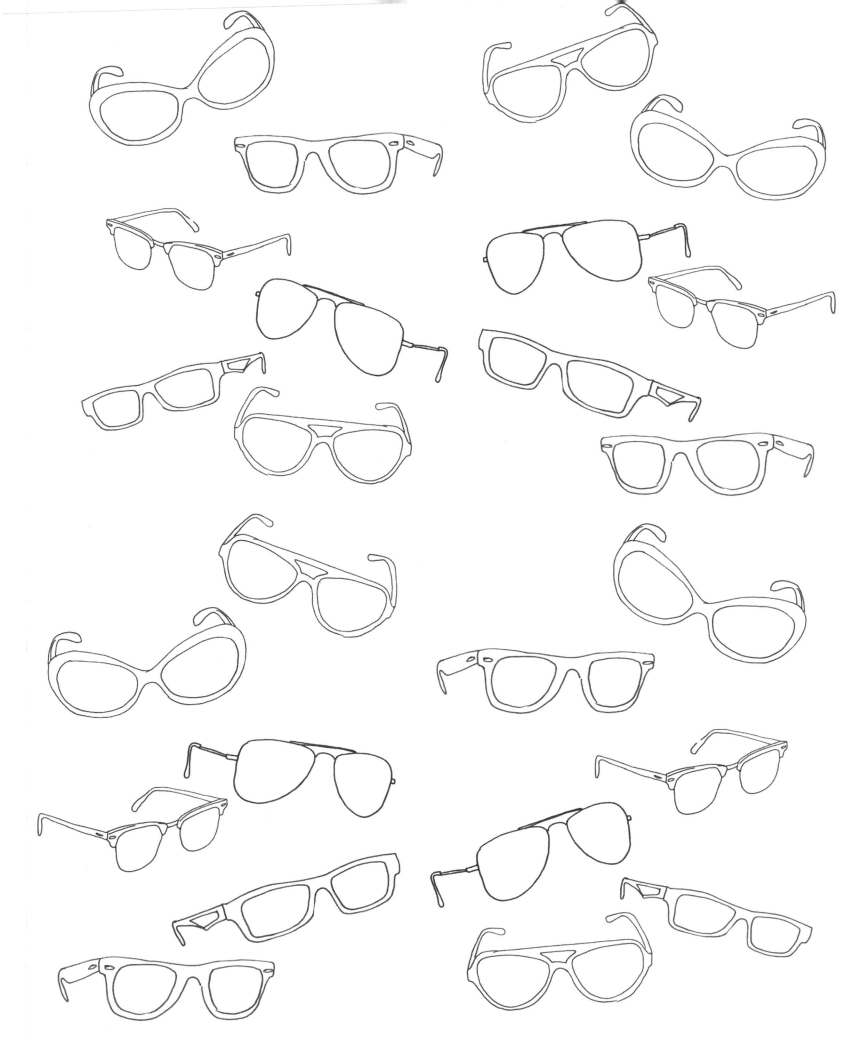

What would this **Dolce and Gabbana**
suede shoe say? Color it in and send a message
to all your fashiony friends.

"Sometimes I feel like Carrie from *Sex and the City.* I sit in front of my computer and ask myself, 'Does the daytime have to be boring and grey?'"

—*Alber Elbaz*

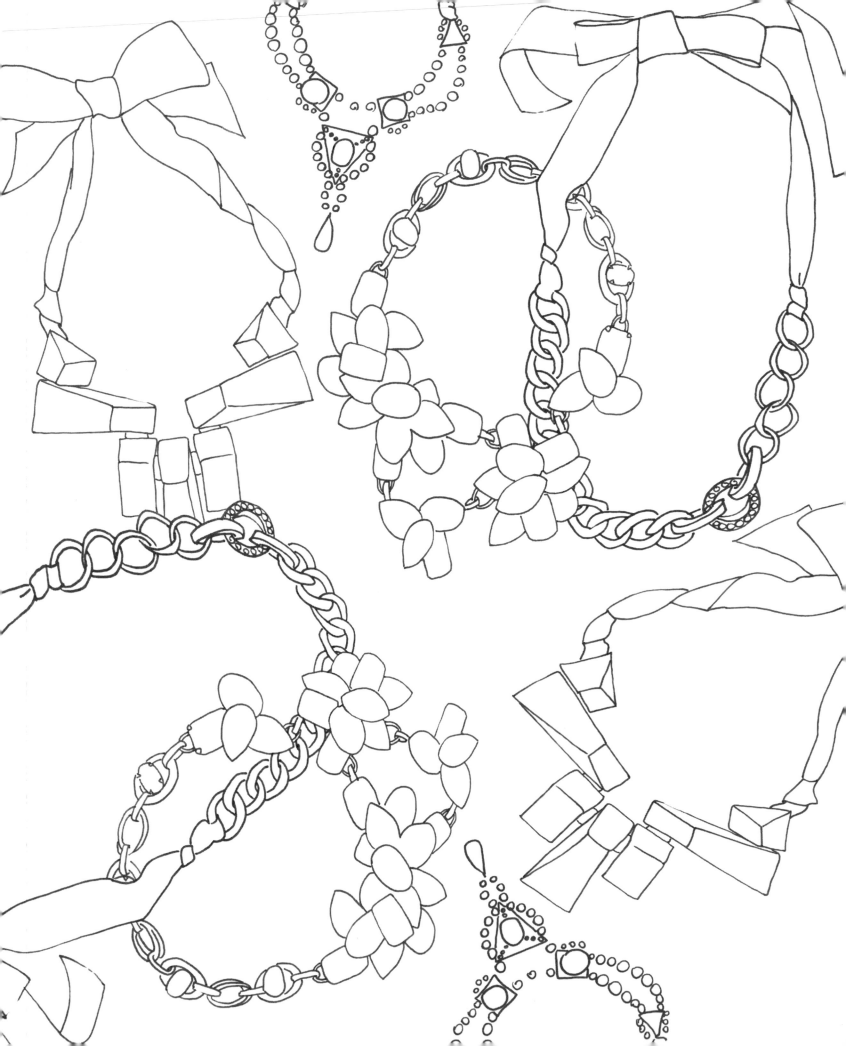

The designer **Stella McCartney** keeps things fresh by serving up a citrus theme in her 2011 runway collection. Add some zest by coloring in the fruity pattern on her chic shirt.

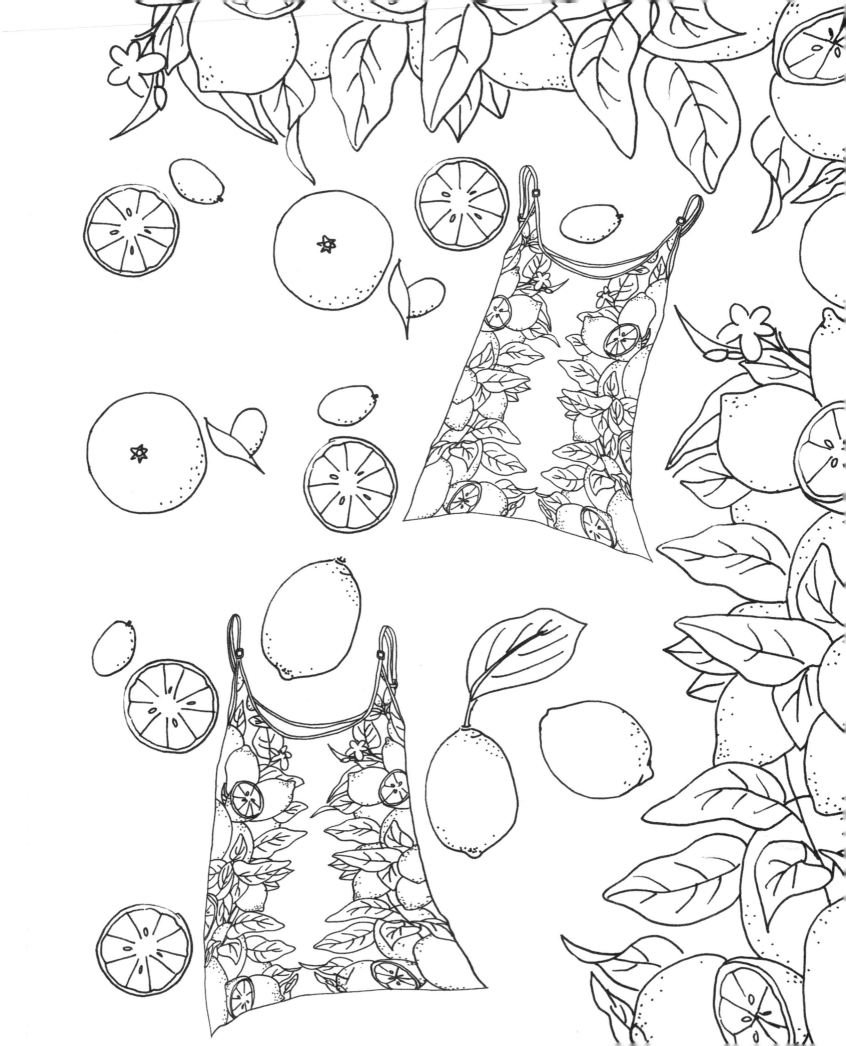

This Italian fashion house weaves a fine legacy. Beautify this **Missoni** fabric with a kaleidscope of colors.

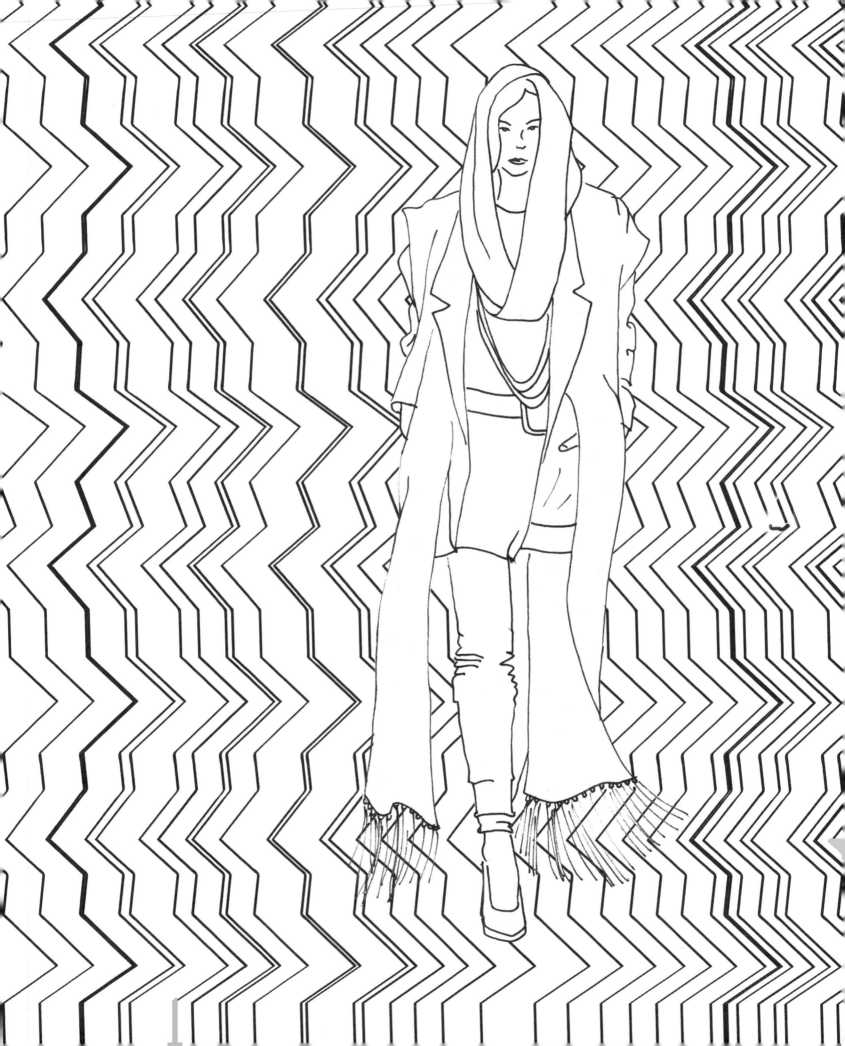

Erdem invites you to a garden party. Enjoy an enchanted afternoon complete with tea, flowers, and, of course, beautiful dresses—color this page.

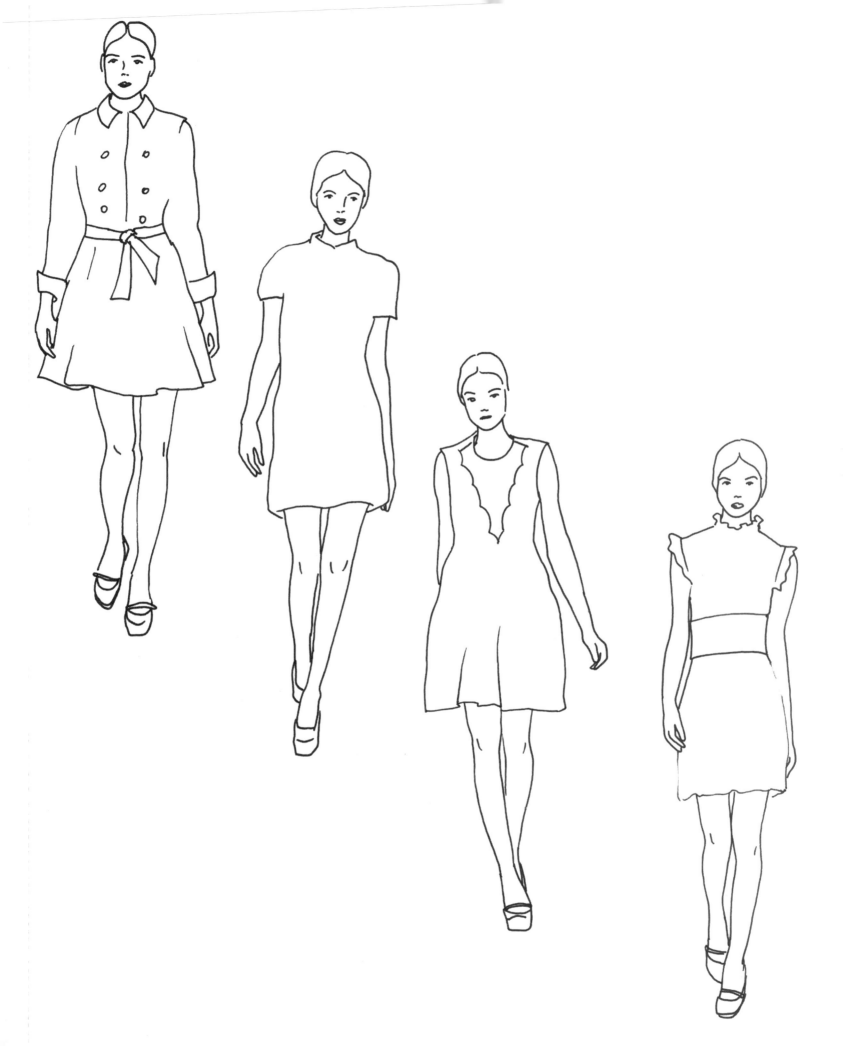

Building the perfect wardrobe is not easy, but the **Céline** designer Phoebe Philo knows what every girl wants: something simple yet sophisticated. Complete these timeless looks and accessories.

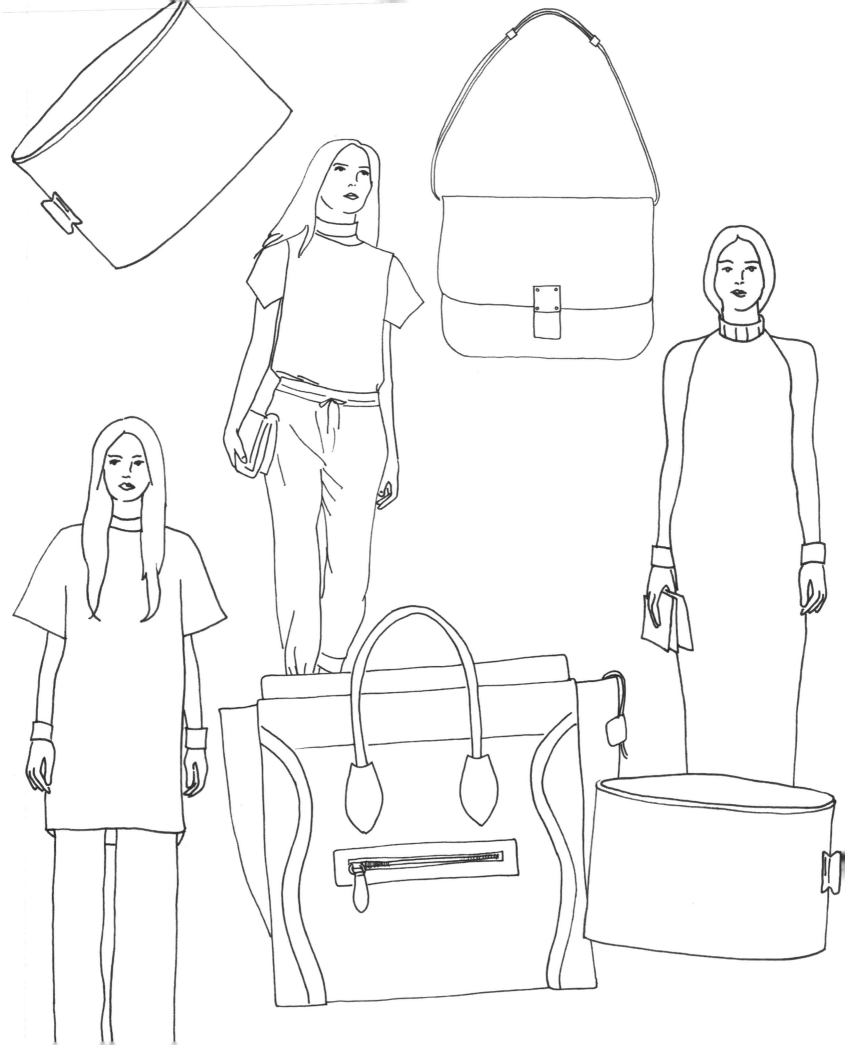

The **Kenzo** girl is feminine and whimsical. And she loves flowers. Give these poppies a pop—of color.

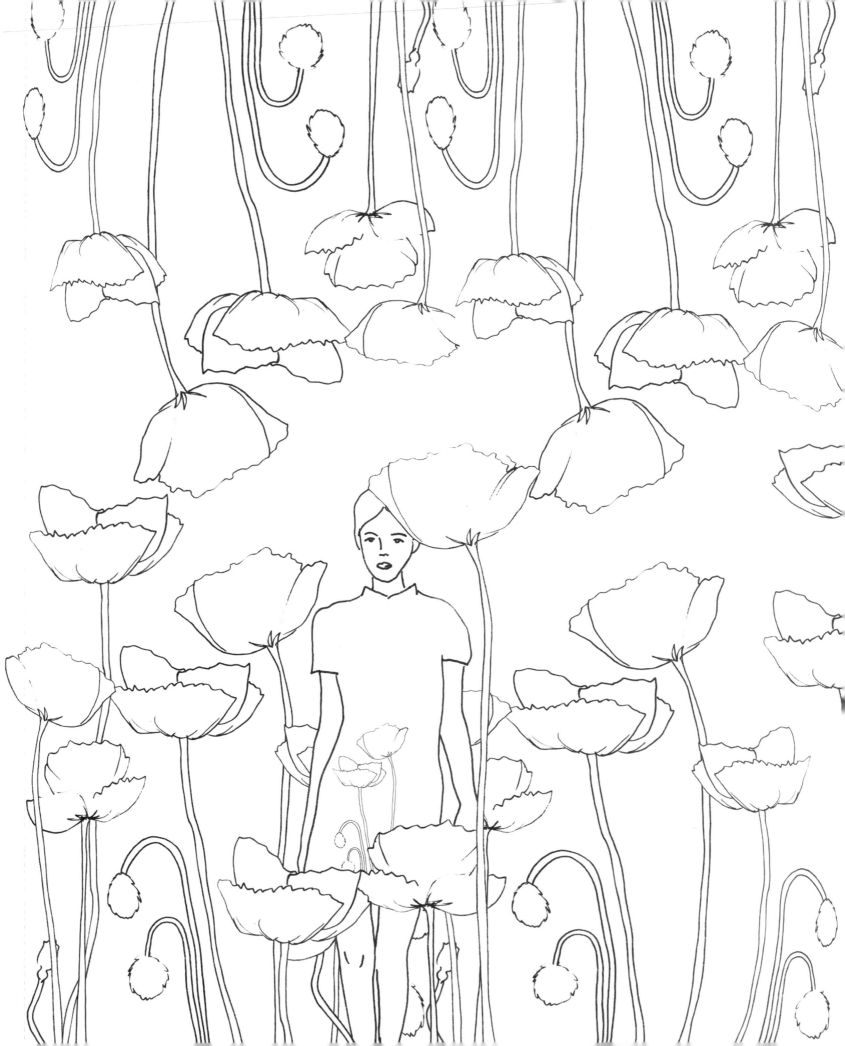

Anything goes — that's the world of **Jeremy Scott.** Whether you're a caveman or a cartoon character, there's something for you. So get your rocks off and add some life to these fantastic looks.

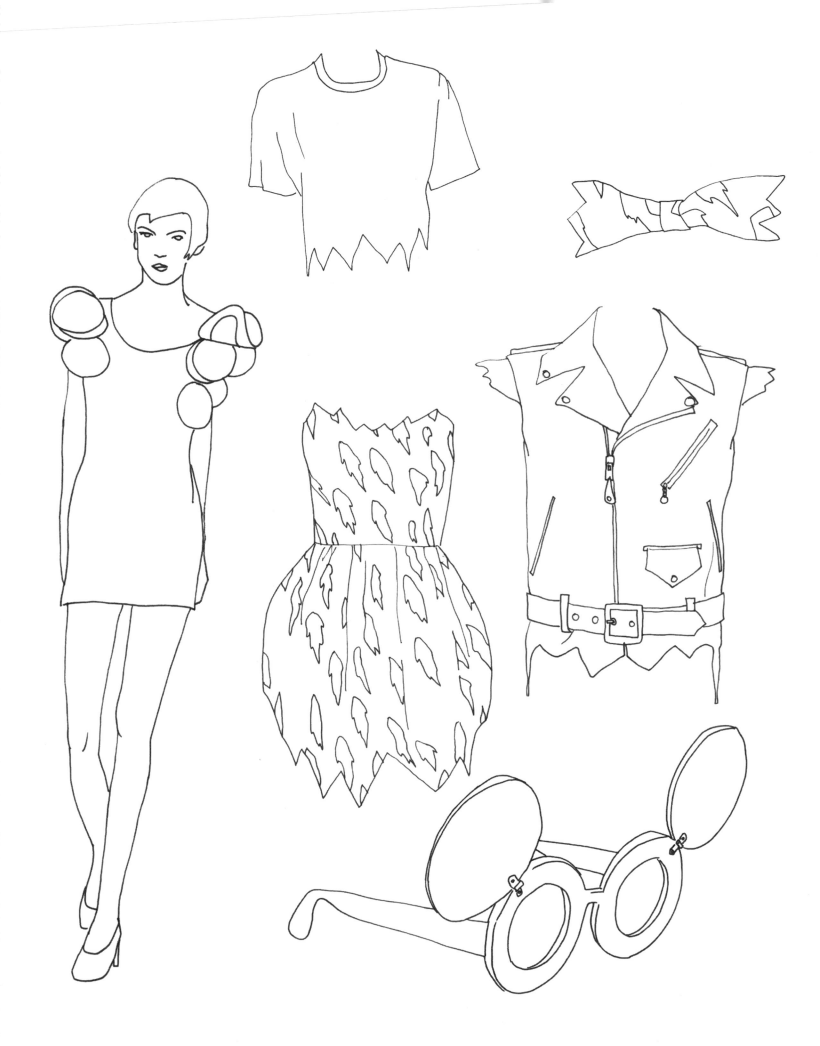

No wallflowers here—
Versace's Donatella
Versace designs clothes
made to stand out on a
night out. Glam up these
disco-ready dresses.

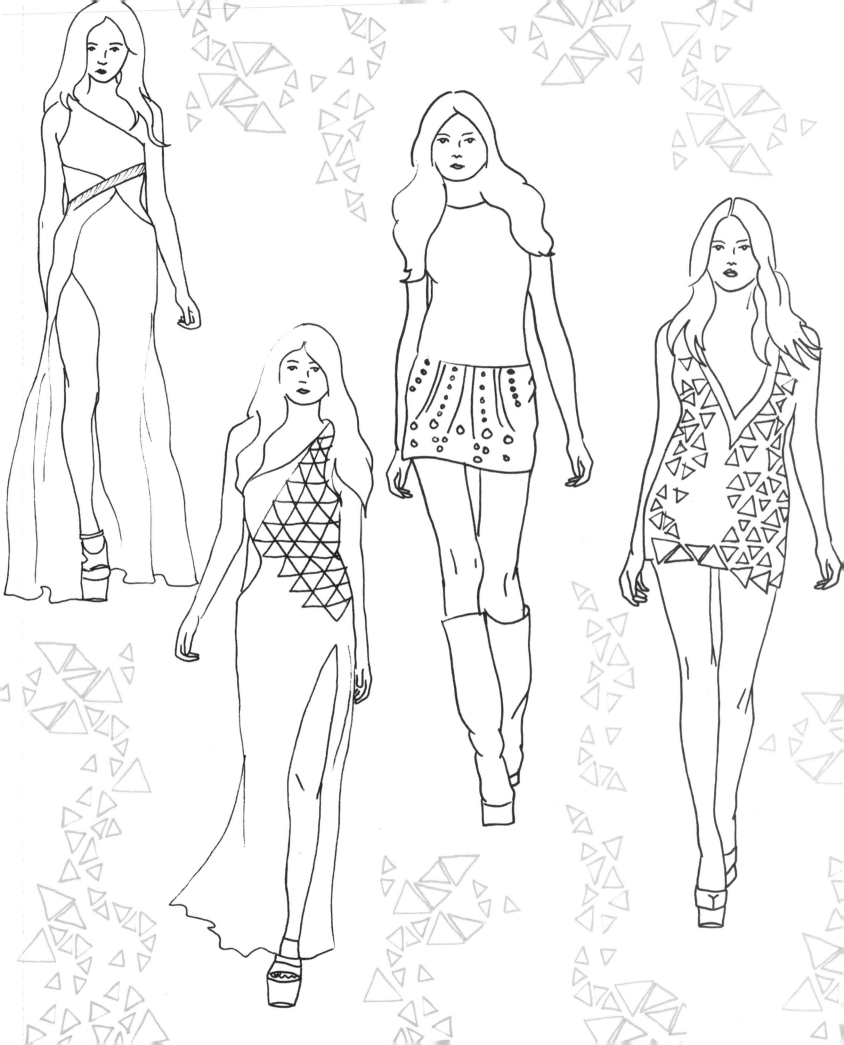

It doesn't get more French than this. **Isabel Marant** is the ingénue's designer of choice. Color these laid-back pieces.

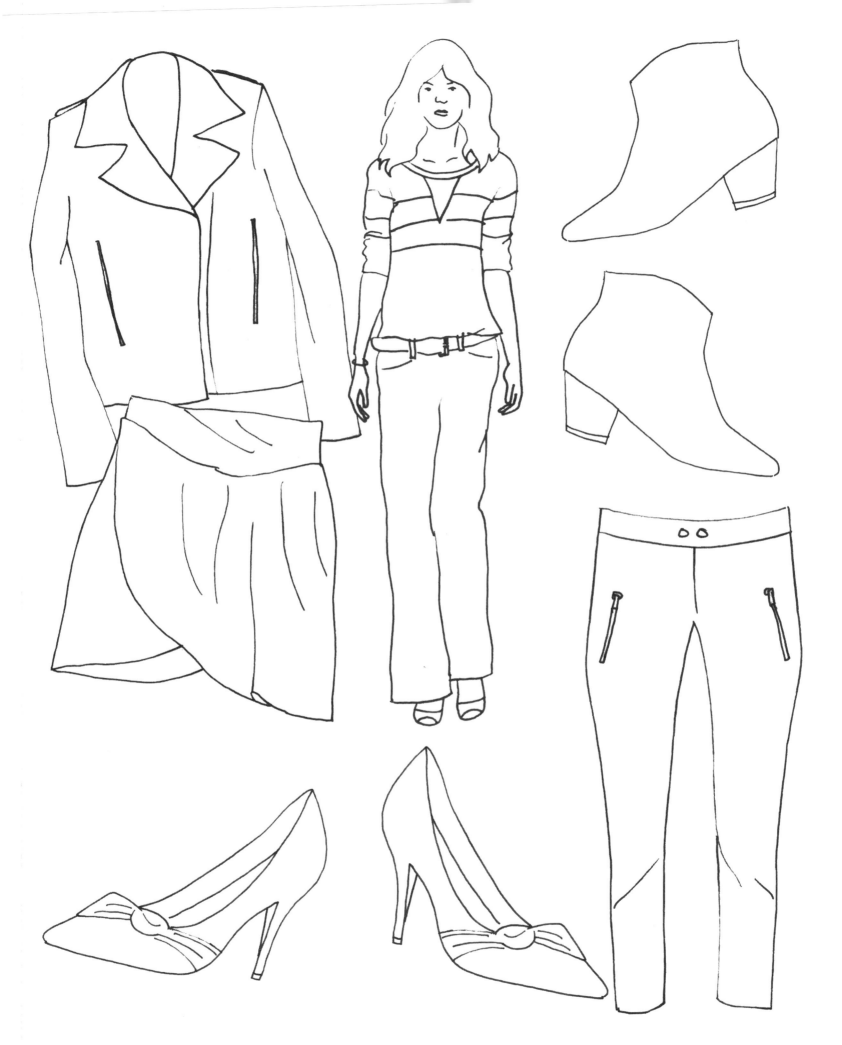

"He knows how to put
Versace forward—
all its values."
—*Donatella Versace on
Christopher Kane*

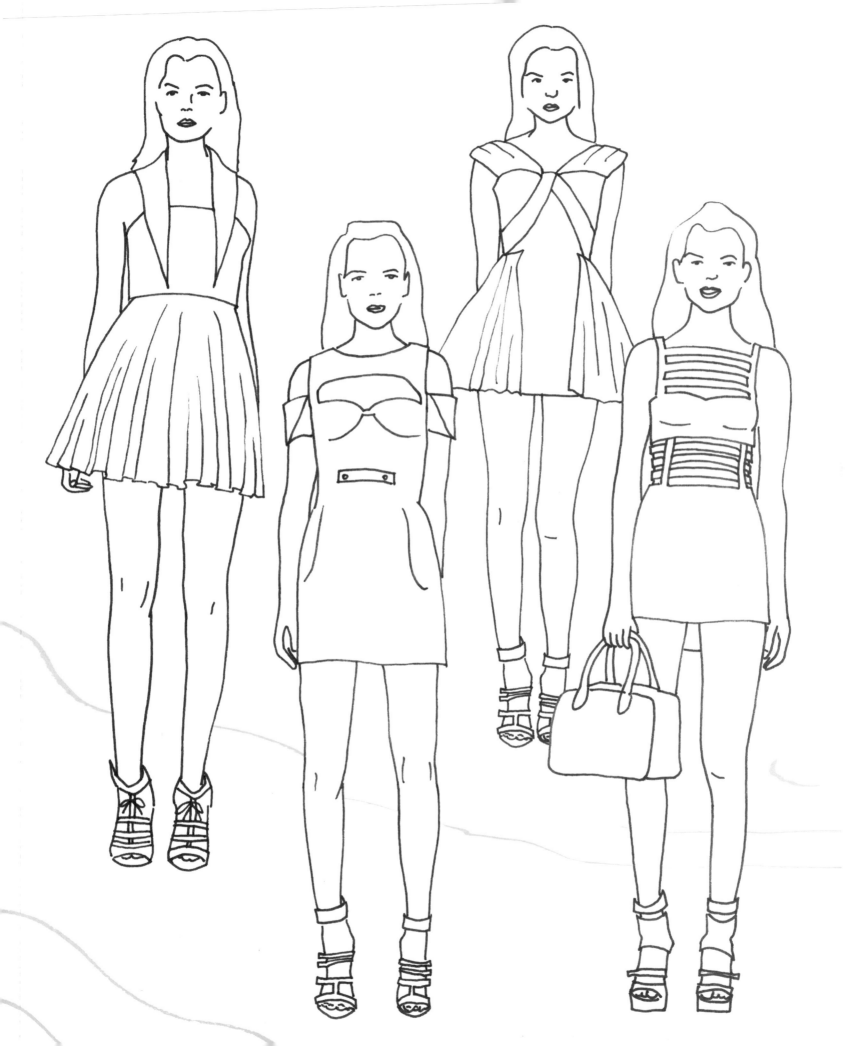

Though it isn't as important as wearing a helmet when riding a bike, the wrong choice of headgear can certainly lead to a fashion disaster. Don't go down that road — color each of these toppers.

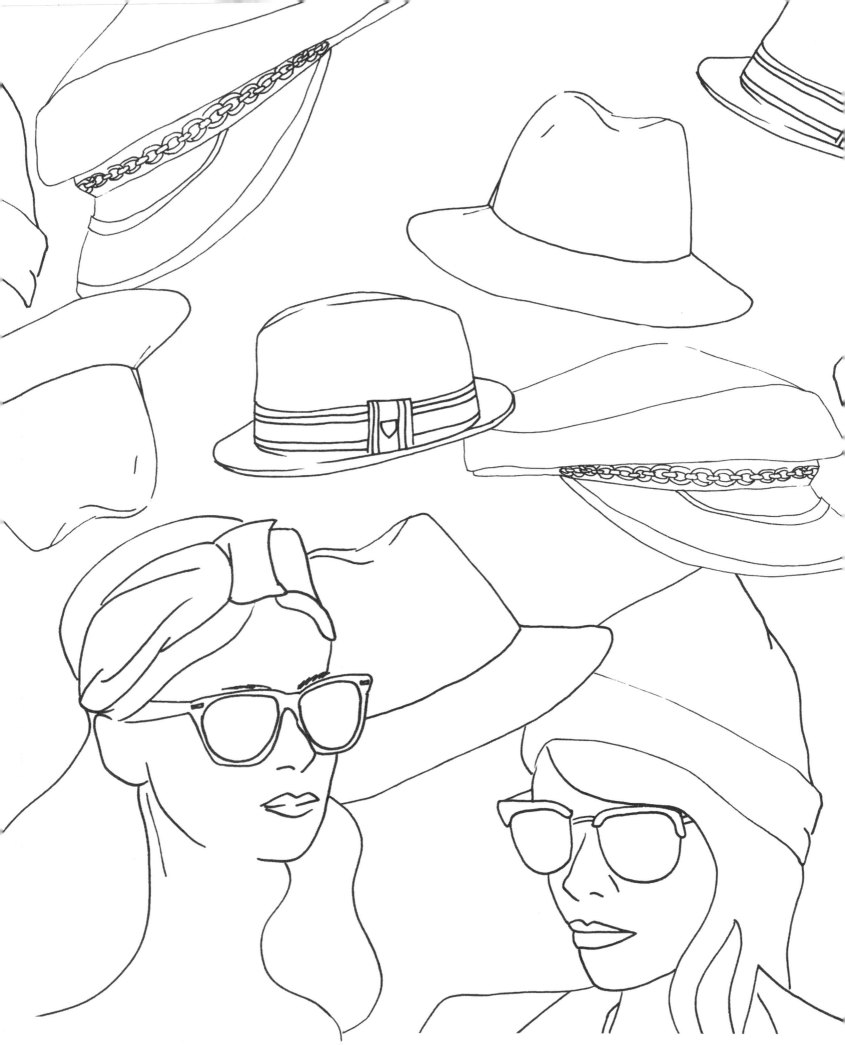

Fancy a party? **Erickson Beamon,** a partnership between Karen and Eric Erickson and Vicki Beamon, has been keeping the party going since 1983. The brand's trademark is a pair of chandelier earrings. Color this festive finery.

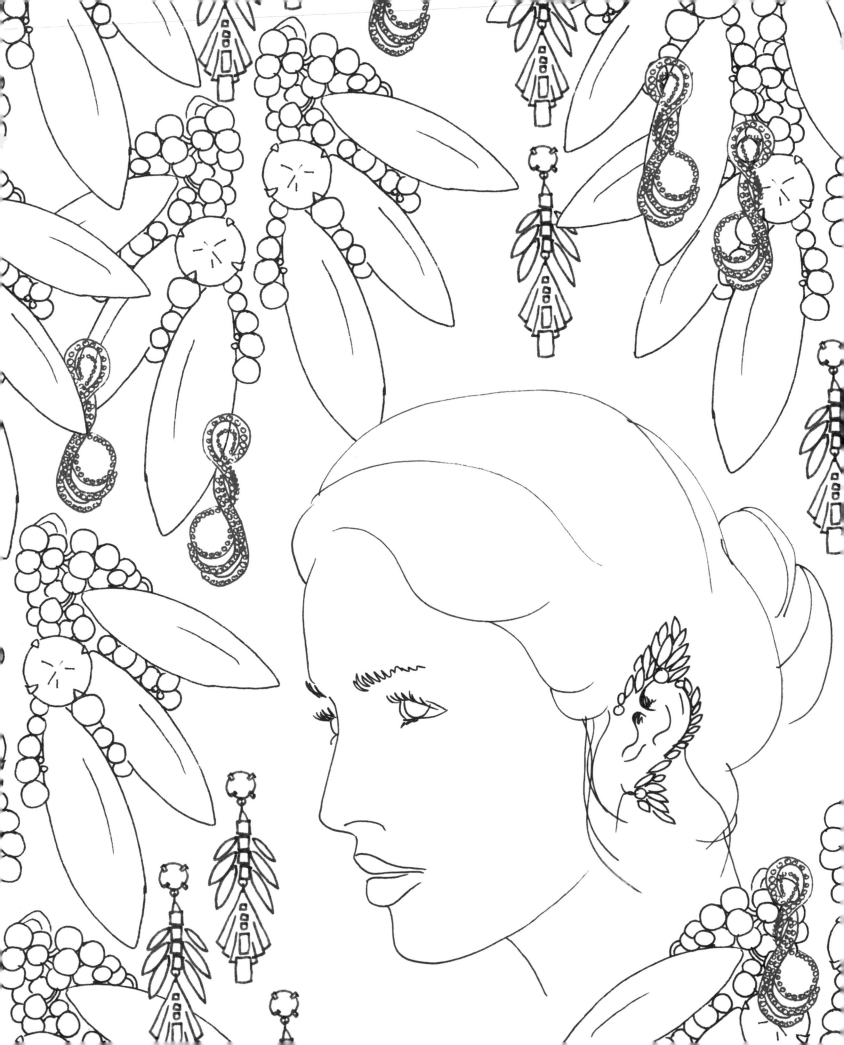

For the **Rodarte** designers Kate and Laura Mulleavy, fashion is about the juxtaposition of light and dark, good and evil, beautiful and seductive. Color this prima ballerina amid the ribbons.

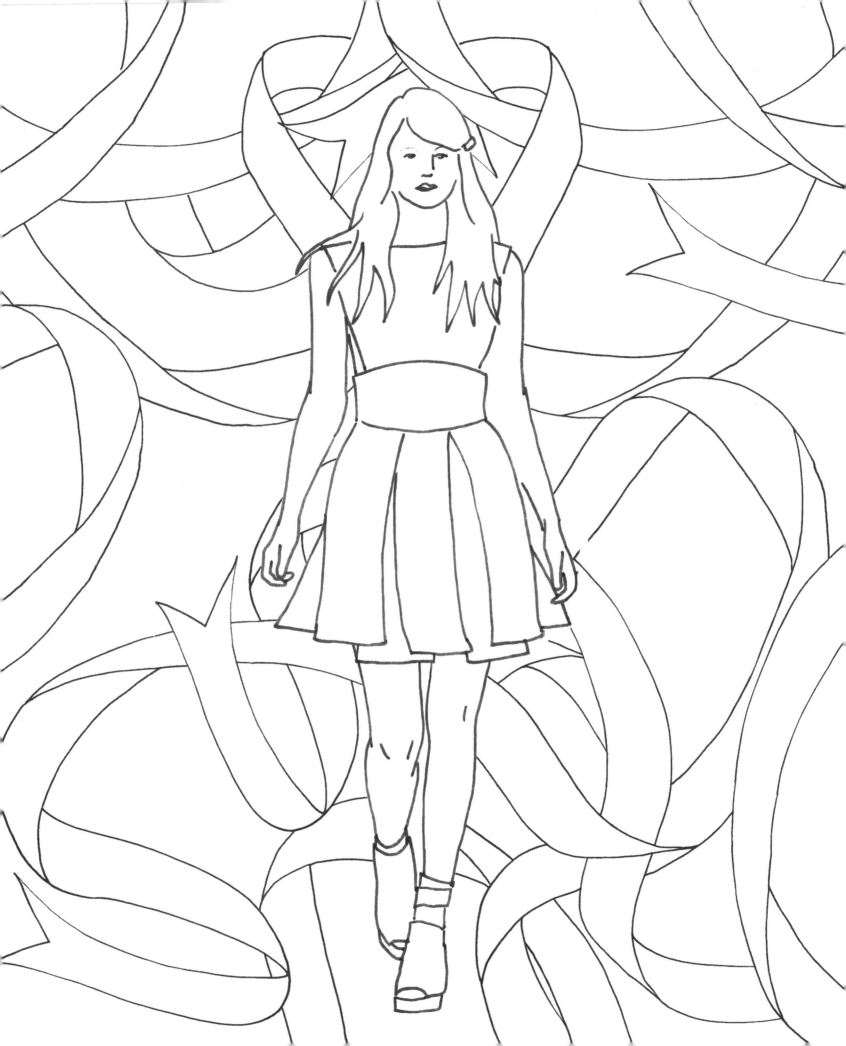

Ready . . . set . . . GO! From showroom appointments to magazine deadlines to designer runway shows . . . color these watches and make it there without a minute to spare.

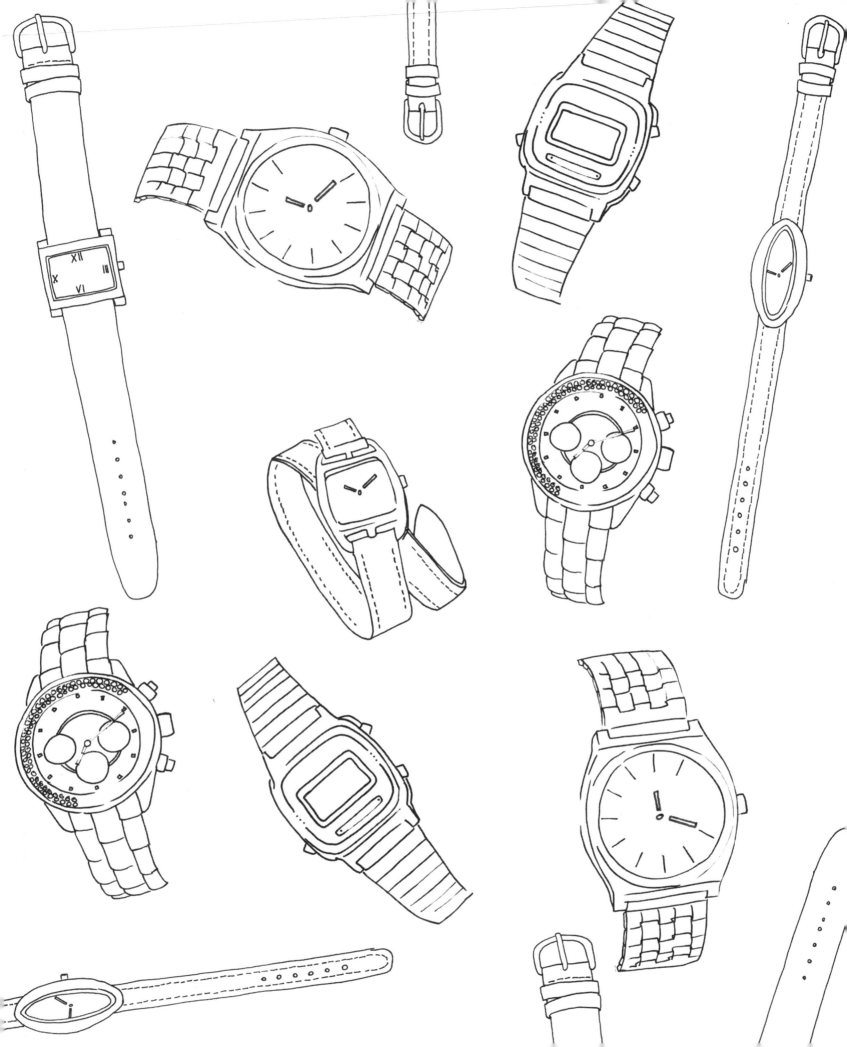

Minimalism is about the
essence of—but certainly not
the absence of—pop.
The **Jil Sander** designers
mix bright colors and shapes to
create a bold statement. Color
this collection in orange, pink,
yellow, blue, and green.

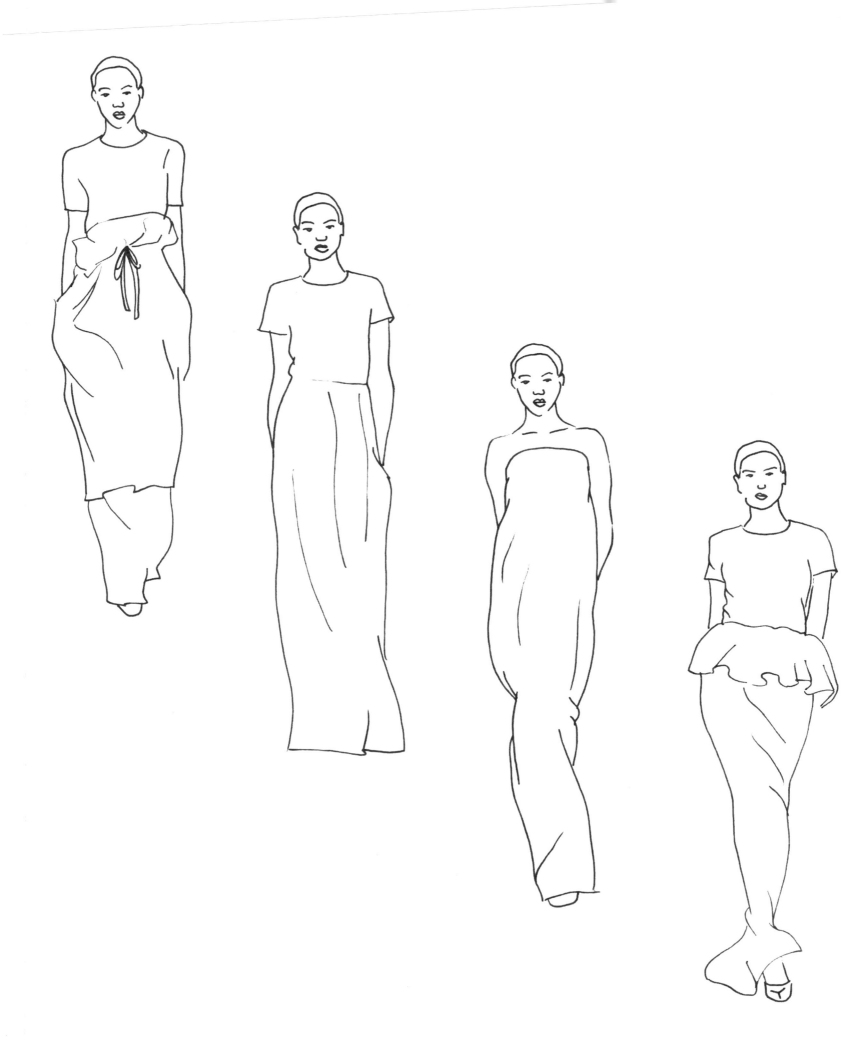

"I want to make
the experience
of buying
and wearing
clothes an easy
experience."
—*Pheobe Philo*

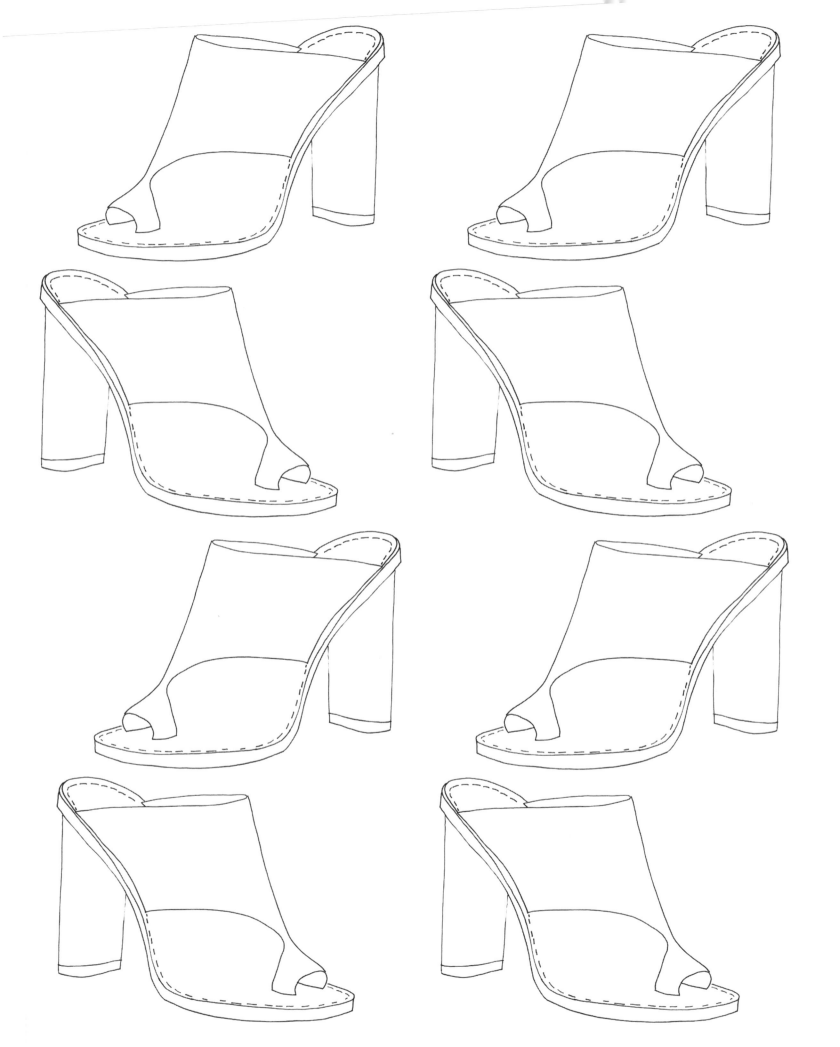

When it comes to fashion, rock-and-roll is forever. Rock chicks get their fix with **Christophe Decarnin's** signature leather jacket for **Balmain**. Now it's your turn to customize your own. Add studs, patches, and stars. And don't be afraid to be bad.

She's so fashion, she even smells like fashion.
Calvin Klein kicked off the unisex buzz
when he released his popular fragrance **ck one**.
Color these bottles to be worthy of your own
cult following.

Comme des Garçons'

signature dot print has been spotted everywhere! Color in this dotted dress and try your hand at a new color palette for the founder Rei Kawakubo and crew.

So, like . . . what are you into?
Fashion can be so confusing.
Why not let these designers make
it a little easier for you? Color the
styles that best fit you. Or color
them all, if that's what you're into.

Punk . . . **Limi Feu.**

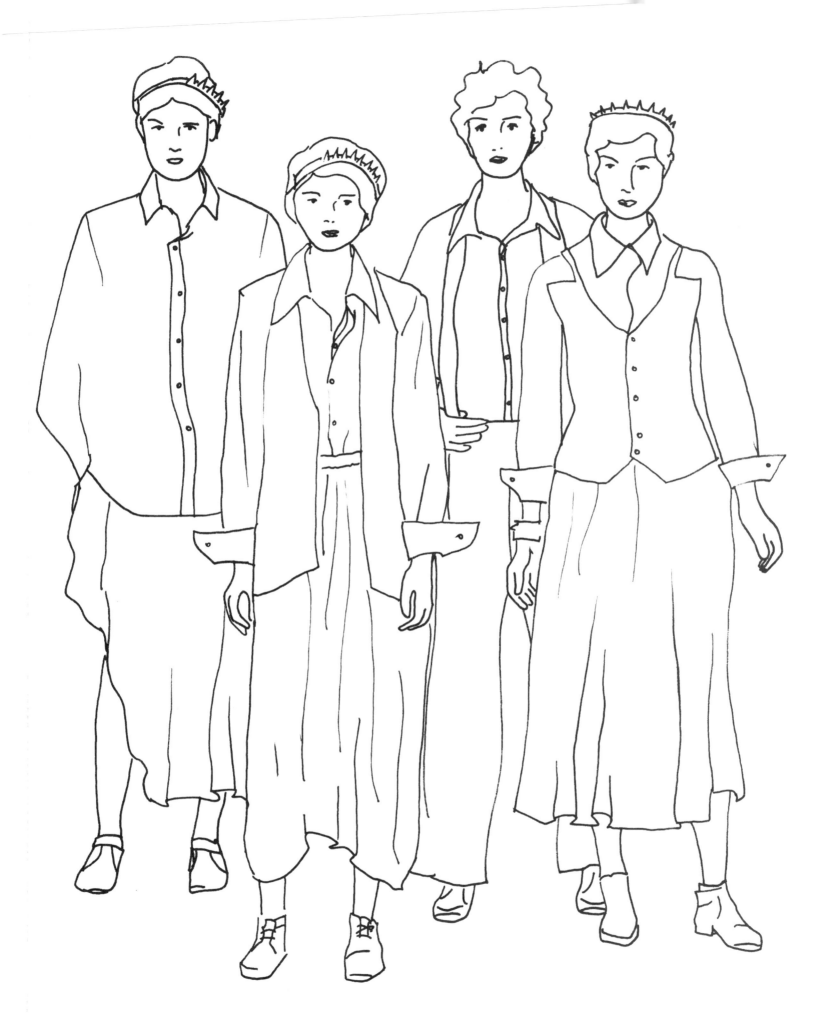

Girly . . . **Chloé.**

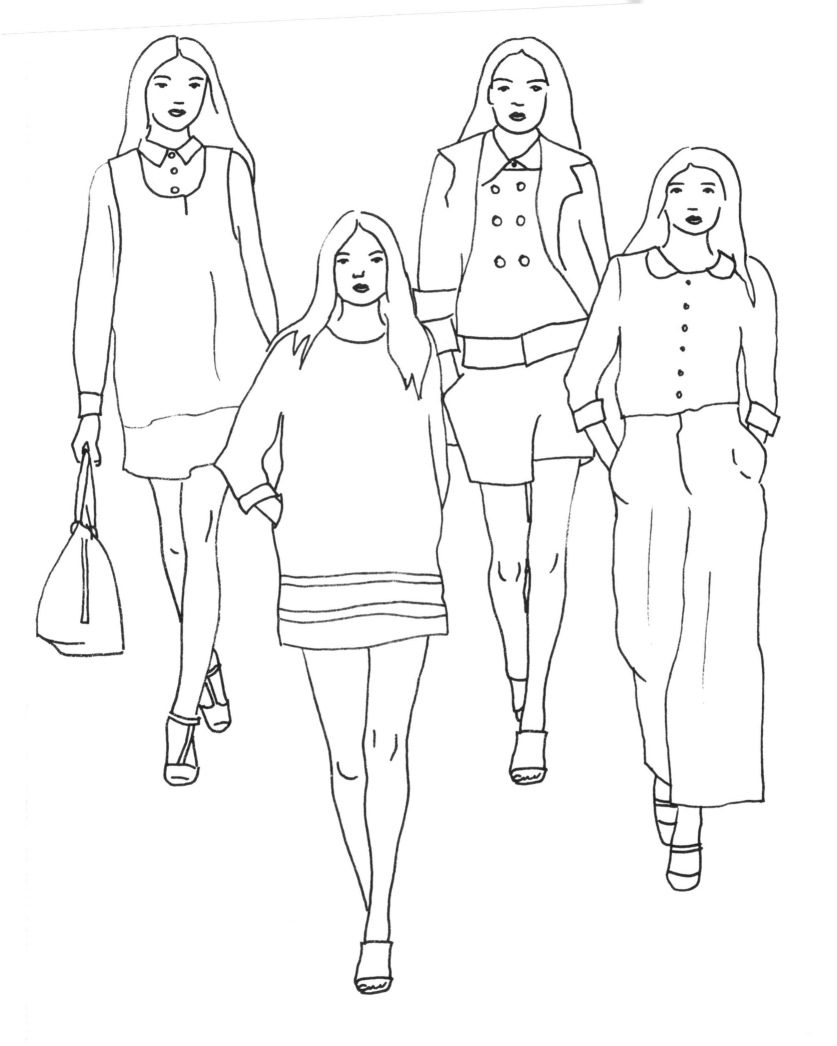

Sexy . . . Haider Ackermann.

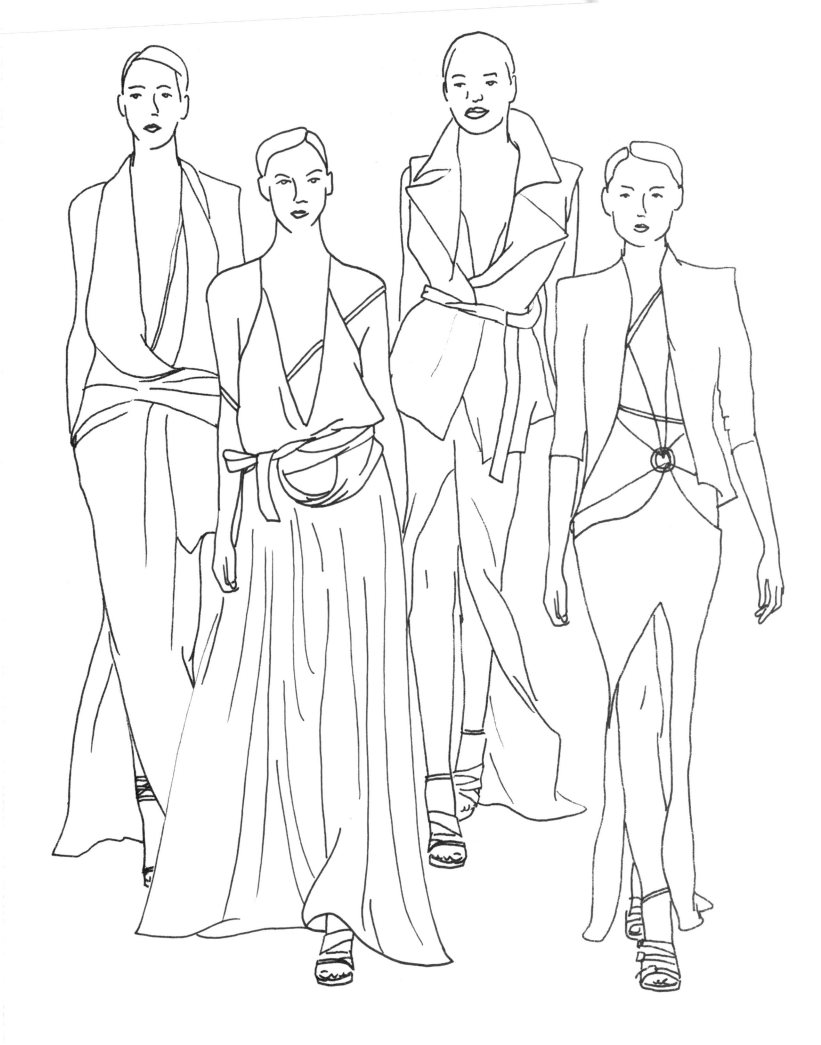

Who says you can't wear socks
in the summertime? Socks and
sandals go together like ice
cream and cake. Decorate these
socks like you would your favorite
dessert. Sprinkles included.

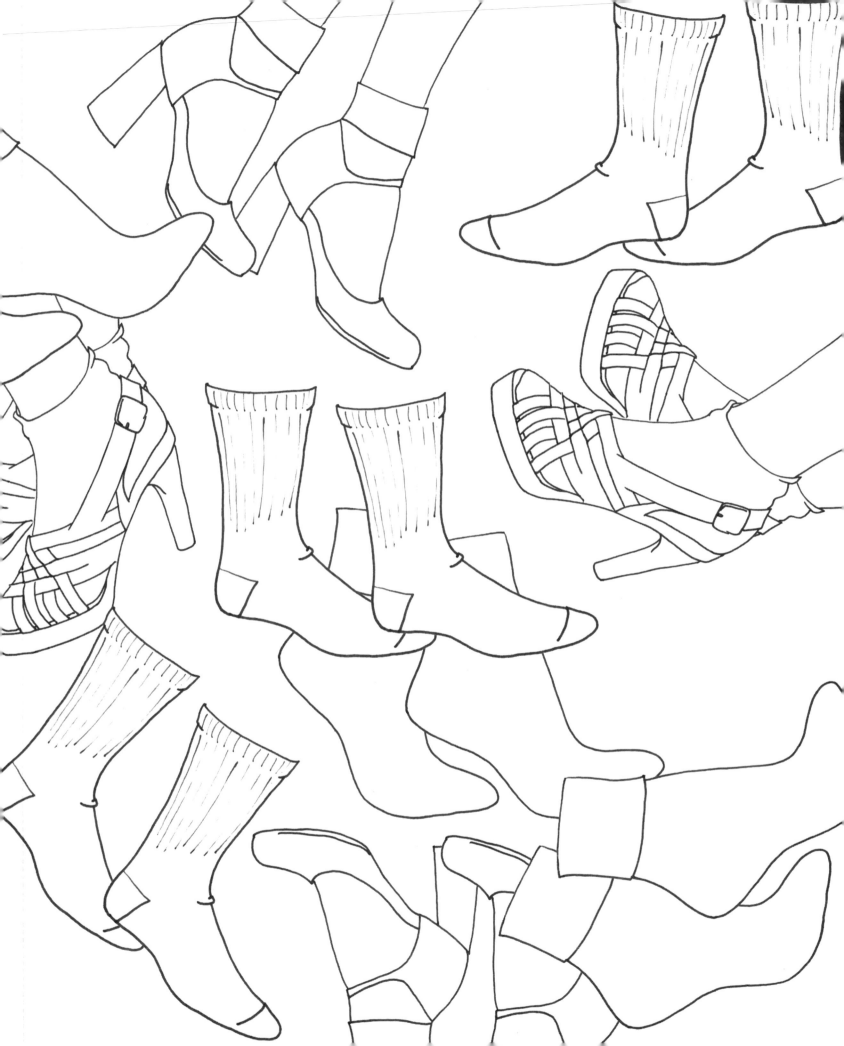

Rag & Bone's co-creative directors, Marcus Wainwright and David Neville, met at boarding school in Berkshire. Their cool-Brit-meets-classic-American style is in a class all its own. Finish these back-to-school essentials.

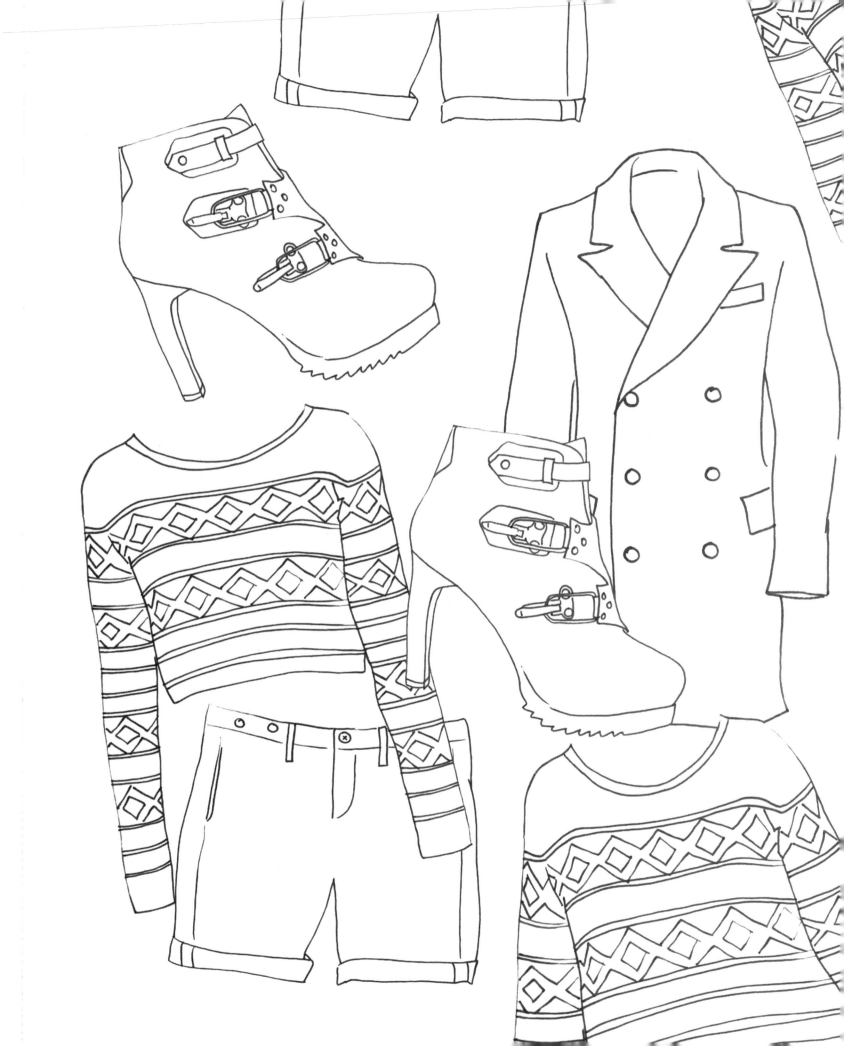

Nothing gets more English than **Mulberry.**
The Bayswater, the Roxanne, and the Alexa bag
and clutch are a tradition—just like afternoon tea.
Decorate these bags in your favorite colors.

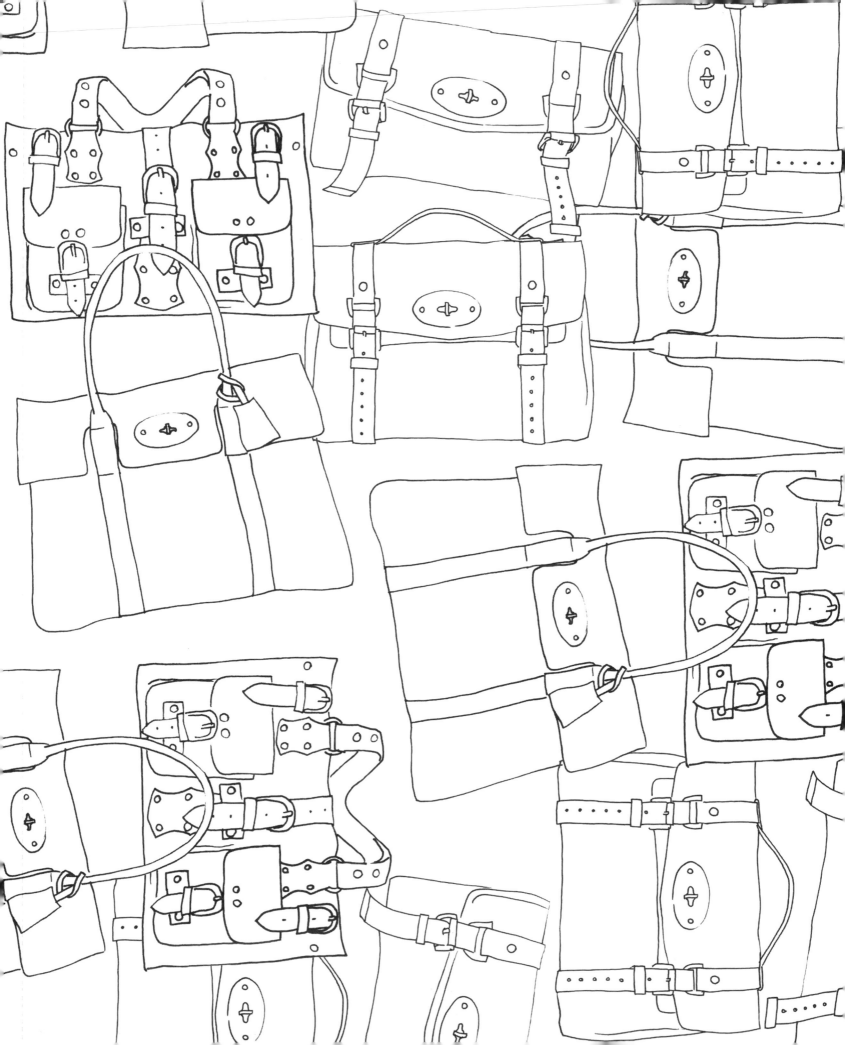